HOW TO PAINT
OILS

STEPHEN ROSE

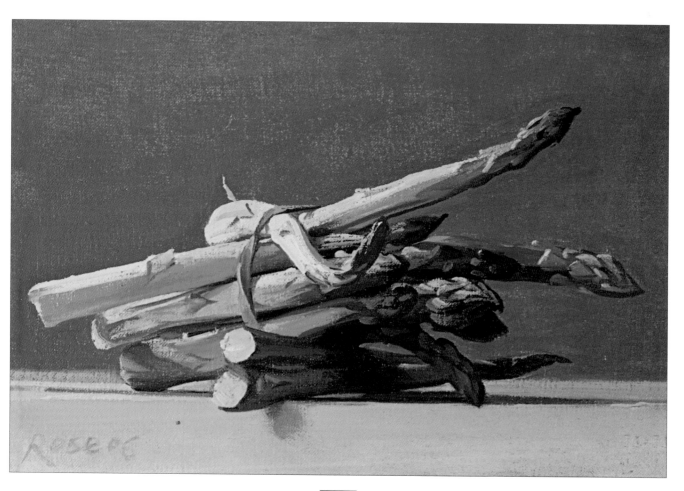

SEARCH PRESS

First published in Great Britain 2008

Search Press Limited
Wellwood, North Farm Road,
Tunbridge Wells, Kent TN2 3DR

Text copyright © Stephen Rose 2008

Photographs by Jonathan Marsh of Pip Designs (pages 1, 2, 3, 6–7, 8–9, 20–21, 26–27, 35, 36–37 and 64) and Winsor & Newton (pages 10b, 15, 16 and 18t); remaining photographs by Debbie Patterson at Search Press Studios.

Photographs and design copyright © Search Press Ltd. 2008

ISBN: 978-1-84448-291-7

The Publishers and author can accept no responsibility for any consequences arising from the information, advice or instructions given in this publication.

Suppliers
If you have difficulty in obtaining any of the materials and equipment mentioned in the book, please visit www.winsornewton.com for details of your nearest Premier Art Centre.

Alternatively, please phone Winsor & Newton Customer Service on 020 8424 3253.

Acknowledgements

Thanks to the team at Search Press: Roz, Katie, Juan and Debbie, whose guiding hands and expertise were invaluable in helping me with my contribution to this book. Thanks to my family and friends for reading my efforts, to Sarah who typed it for me and to my students of the past twenty years, without whom I might never have gathered the experience to furnish this book.

Publishers' note

All the step-by-step photographs in this book feature the author, Stephen Rose, demonstrating oil painting. No models have been used.

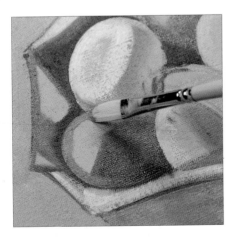

Cover
Pomegranate
20 x 25cm (7¾ x 9¾in)

Page 1
White Tulips
51 x 41cm (20 x 16¼in)

Page 3
Asparagus
26 x 20cm (10¼ x 7¾in)

Printed in Malaysia

Contents

Introduction

Before the Renaissance, painting was considered to be a craft. It was only during this extraordinary period that painters and sculptors began to enjoy the status of artists and men of genius. The realisation that a painter might also be a genius had a profound effect on the perception of painting as an activity, making it a suitable accomplishment for the well-to-do. Painters now had students, and the amateur was born.

Today, painting is no longer seen as the pinnacle of artistic expression. The term 'artist' is used in an increasingly broad context and art as an activity has never been more popular. The amateur and the hobbyist keep the paint manufacturers busy developing new products and extending their ranges. Two of the greatest contributions to the universal availability of paint are the collapsible metal tube and the mechanised milling of paint. These have allowed paint to be made on a large scale, stored and transported, resulting in painters no longer needing any technical knowledge of the characteristics of paint. Indeed, the general trend in western art has been to regard such knowledge as inhibiting creativity.

In spite of this, many painters have become interested in the breadth and scope of materials, both ancient and modern. Through this book, my wish is to provide the beginner with an elementary understanding of oil paint and its potential; overburdening the reader with detailed information about the refinements of oil painting, composition and the aesthetics of picture making generally simply inhibits them at an early stage. It is better to address problems of technique and materials as and when the need arises. All the suggested paints are widely available and selected to give the beginner the broadest spectral range with the smallest number of colours. Commercial canvases and primers are designed for direct application with the minimum of preparation.

I have avoided providing prescriptive instructions in the demonstrations; they are meant only as an explanation of my approach to the subject. Remember, one paints with the emotions and no two people will react in the same way; you must have something to say and develop your own voice. All the subjects of the still-life demonstrations are readily available household objects. Most are simple forms that don't require a high standard of draughtsmanship and can be set up easily on a kitchen table.

Finally, I would encourage you to visit galleries and acquaint yourself with a wide range of painting styles. Find out what it is you like and what you want to pursue. Painting will help you to understand how pictures are made and the intention and concerns of the artist who made them. Good luck, and enjoy!

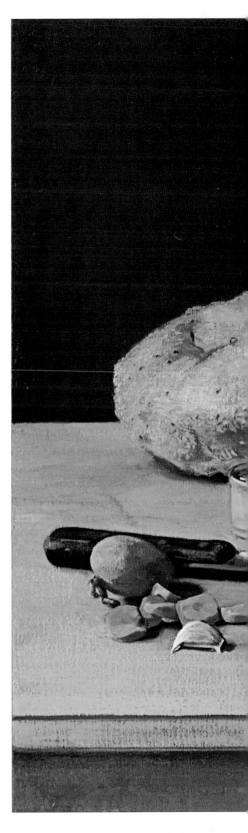

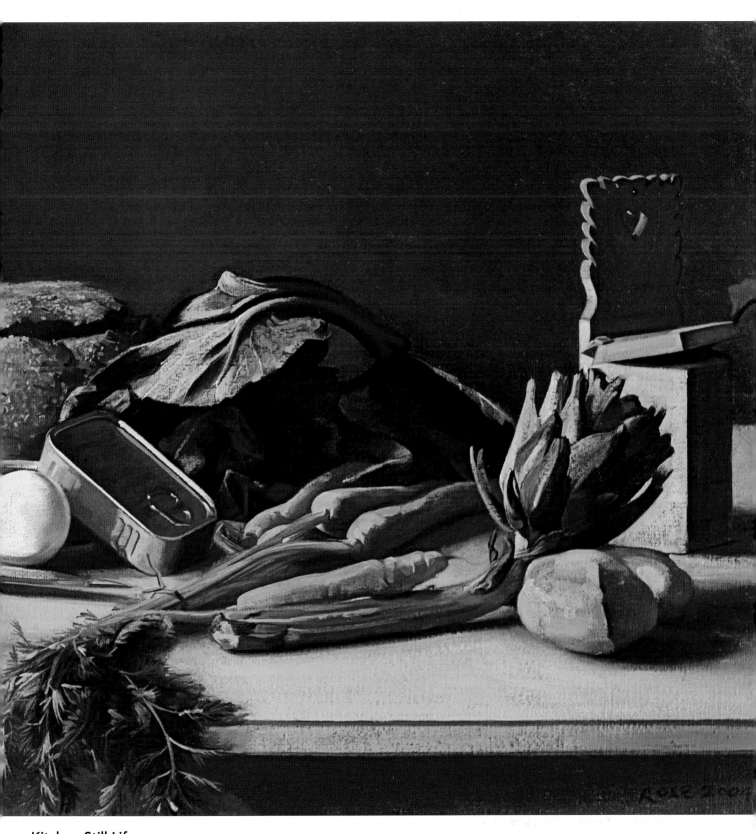

Kitchen Still Life
66 x 46cm (26 x 18in)

In this painting, the warm colours of orange, yellow ochre and tomato red complement the cooler blue-greens of the cabbage. The reflective surfaces of the tins and the blade of the knife transfer warm colour into the lower half of the picture. Note the echoing shapes of the cabbage, bread, artichoke and the handle of the wooden spoon in the salt cellar. The carrots carry the colour theme of orange-green and lead you into the picture with colour intervals and texture.

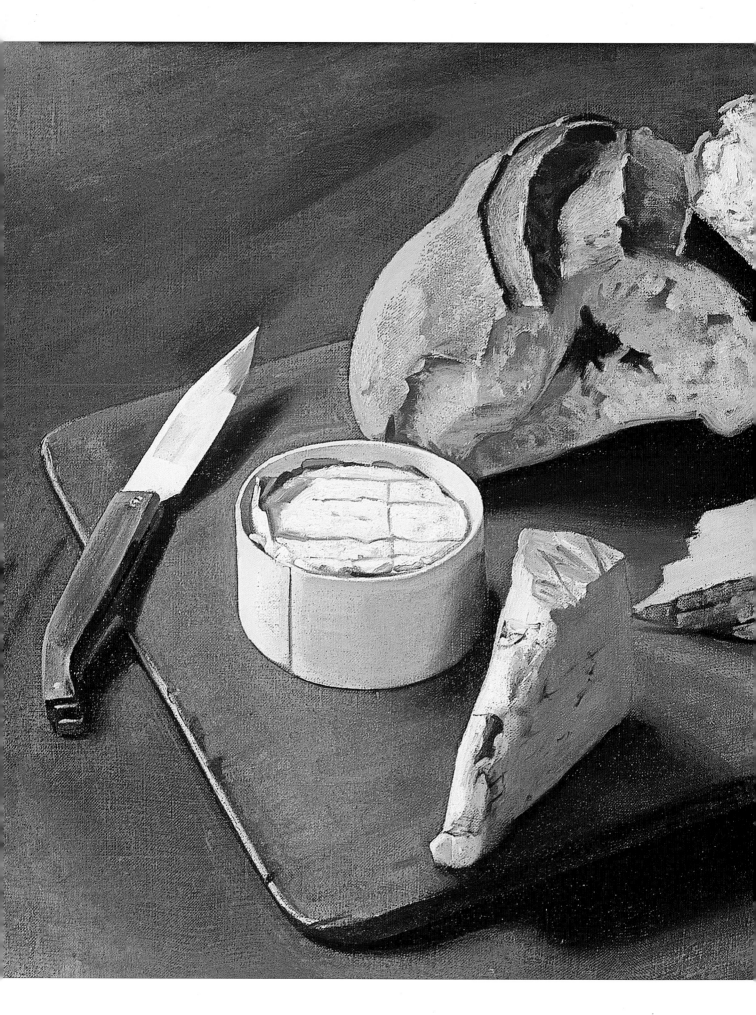

Cheeseboard
46 x 35cm (18 x 13¾in)

In this picture of a cheeseboard, I have kept to earth colours and the dark grey background acts as a foil to the subtle colours of the bread and cheese. The dynamic composition of diagonals formed by the bread, cheese, knife and board all rotate around the central dark void. This painting is a *tour de force* of various textures and surfaces.

Materials

The basic materials of the oil painter are:

• paints, brushes, supports (canvases, boards, etc.)
• medium, solvent and an easel.

Cost is usually a consideration, so buy the best paint you can afford, then the best brushes. If you need to economise then I suggest you use a simple support such as primed hardboard, cardboard, mountboard or paper.

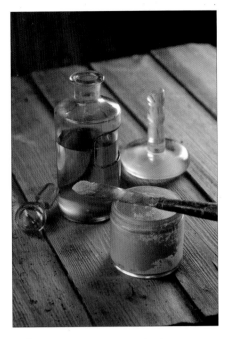

The basic ingredients of oil paint: linseed oil and pigment.

Oil paints

All of the colours I have used in the projects in this book are shown on the facing page. I have used artists' quality paint, but student quality paint can be used if you are on a tighter budget.

The production of paint is of a generally high standard and many manufacturers have several hundred years of experience and research behind their product, developing new ranges and new pigments. There is an increasing number of artisan producers of high-quality paint that is made by hand in small batches.

All paint is classed by pigment number, for example PK11. Look for this on the paint label or on the manufacturer's technical sheet. You will also be confronted by various trade descriptions, such as raw sienna, monastral blue, etc. The more common ones refer to the origins of the pigment, for example raw sienna from the region around Sienna, or their chemical origins, for example cadmium yellow. Some are named after their original district of manufacture (Cremnitz white, Prussian blue); others are simply fanciful inventions (Caesar purple and Veronese green). You might see the word 'lake' incorporated in the name; this means the colour is semi-transparent and has a high tinting strength. 'Hue' is used to indicate that a colour has the appearance but not the performance of an expensive pigment which it has replaced; for example cadmium red hue is usually ozo red, a cheaper pigment. Sometimes a pigment is supplemented by another because it has been withdrawn due to its hazardous nature.

Chemical composition gives paint certain characteristics of opacity, translucency, covering power, mixing qualities, tinting strength, light fastness, permanence and drying time. These terms are explained below:

Tinting strength:

the ability to stain and modify other colours.

Drying time:

this varies according to the paint's chemical composition. High amounts of cobalt or manganese will speed up drying time. Manganese is a trace element in earth colours.

Covering power:

the opacity of a pigment when brushed out over a given area.

Permanence:

a pigment's stability; a measure of how much it fades or changes colour over a period of time.

Mixing quality:

a pigment that is good in mixes holds its value and hue with other pigments and is not overwhelmed by them.

Opacity/translucency:

the degree of transparency of the paint.

Yellow ochre light PY42: naturally occurring earth, varies from buttery yellow to dark straw depending on source. Semi-transparent, permanent, dominant in mixtures, fast drying, excellent covering power.

Gold ochre PY43: naturally occurring earth, golden brown colour, opaque, fast drying, permanent, moderately good covering power.

Burnt sienna PBr7: deep warm red-brown, transparent, permanent, fast drying, strong tinting quality.

Terra rosa PR101: one of many native Italian red earths, linked to volcanic activity. Fast drying, opaque with excellent covering power, dominant in mixtures and permanent.

Burnt umber PBr7: deep chocolate brown, transparent, permanent and fast drying, good covering power.

Ivory black PBk9: cool black, producing bluish tones, semi-opaque, permanent, good covering power, slow drying.

Winsor lemon PY3: brilliant yellow lake, semi-transparent, dominant in mixes producing strong tints without unduly lowering tone, permanent and slow drying.

Cadmium yellow PY35: various shades from deep egg yolk to pale lemon. Opaque, good covering power, strong colour in mixes, permanent and slow drying. Highly toxic.

Cadmium scarlet PR108: various shades of red from plum to orange-red. Opaque, good covering power, strong colour in mixes, permanent and slow drying. Highly toxic.

Alizarin crimson PR83: transparent, poor body, slow drying, excellent tinting strength, dominant in mixes, permanent, moderate covering power.

Cerulean blue PB35: similar characteristics to cobalt blue from which it derives. Slightly more opaque than cobalt blue with a weaker green-blue cast.

Prussian blue PB27: good tinting strength, moderate covering power, very fast drying, permanent, transparent. (Note: a little white results in a blue similar to French ultramarine; cannot be mixed with alkali colours, vermilion, cadmiums and mars colours. Unavailable in acrylic.)

Cobalt blue PB28: exquisite colour, semi-transparent, reasonable covering power, good glazes, quick drying, weak in mixes, permanent.

French ultramarine PB29: transparent, permanent, slow drying, good tinting strength, moderate covering power. (Note: not to be mixed with flake white.)

Zinc white PW4: semi-opaque, cold white, moderate covering power, produces excellent tints. Will crack if used as an impasto, but will produce very flexible films when thin. Slow drying, permanent.

Titanium white PW6: opaque, cold white, excellent covering power, will dominate many colours producing chalky mixes, moderately slow drying, permanent.

Flake or Cremnitz white PW1: highly toxic, handle with extreme caution. A pigment with a unique combination of qualities, warm creamy white, combining good body with flexible opaque films. Produces excellent pastes for impasto application, fast drying, permanent, good covering power.

Brushes

Nowadays, most brushes are mass-produced by machine, although specialist brush makers, including Winsor & Newton, will still select hairs and assemble brushes by hand. There are three basic shapes: round, filbert and flat (or square). You will probably need at least one of each of these – more, if possible, in a variety of sizes. The length of hair varies across all shapes, and generally the longer the hair the more flexible the brush. There are three main types of hair: hog, sable and synthetic. Although I prefer to use hog and sable brushes (see below), synthetics and semi-synthetics offer good alternatives to sable at a fraction of the cost.

Sable brushes

Black or red sable brushes are available. They are useful for applying paint accurately and for blending; they 'brush out' the paint, leaving few marks. Use them for glazing and varnishing, but not on abrasive, coarse surfaces or with a scrubbing action.

Hog-hair brushes

Hog-hair brushes have stiff hairs and are hard-wearing. They are the best brushes to use with oil paint, either undiluted or mixed with turpentine, on abrasive surfaces. Chinese hog is generally considered to be the best.

Synthetic and semi-synthetic brushes

Acrylic is the most widely used material for synthetic brushes. They will endure rough treatment, but have many of the characteristics of sable. If well kept, a synthetic brush will keep its spring and shape better than most other brushes. However, if the hairs become bent they are more difficult to straighten. Semi-synthetics are made from a mix of sable and synthetic fibres, and combine the best qualities of each; they have the flexibility of sable, are soft enough to work the paint and retain their original shape well.

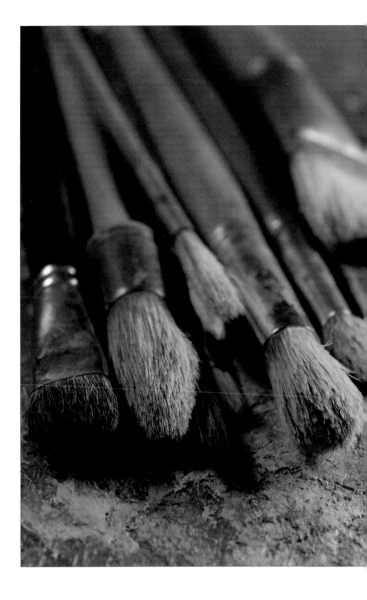

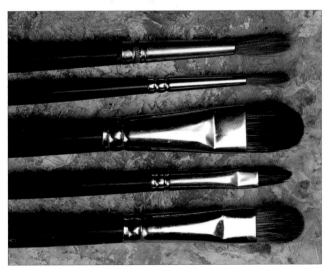

A selection of sable brushes.

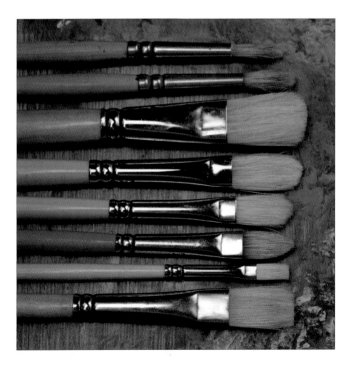

A selection of hog-hair brushes.

Shapes of brushes

Flat or square brushes: useful for constructed mark making (in which the 'square' marks of the square brush can be used to emphasise the construction of a form, for example direction and plane) and accurate definition during the application of colour.

Round brushes: the oldest brush shape, it delivers a lot of paint to an area. Good for combining a broad application of colour with the possibility for both long, sensuous lines and pin-point application.

Filbert brushes: these are slightly rounded and are good for the alla prima approach (see page 33). This type of brush allows you to apply a lot of paint with accuracy. You can also draw with the point and side of the brush. A very good multi-purpose brush.

Palette knives

The best quality palette knives are stainless steel. They are available in a variety of shapes, which can be classed as either trowel or spatula. Cranked blade palette knives have flat, steel blades with a cranked shaft. These are useful for keeping your hand away from the surface while painting. Use flat knives for mixing and gathering large quantities of paint, and also for scraping off paint from the surface of a picture.

Paint can be applied with a palette knife to give a roughcast texture, broad sweeps of paint, dabs of raised paint or, with careful masking, broad blank masses. The trowel-like characteristics have a breadth that cannot be matched by a brush.

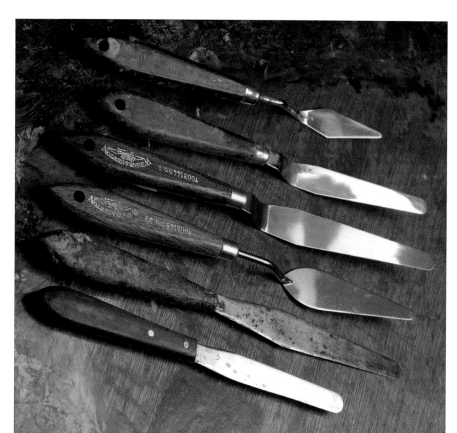

A selection of palette knives.

13

Cleaning and storage

Brushes can be expensive and should be looked after. When you have finished painting, wipe excess paint off your brush on to a lint-free rag or cloth, having initially cleaned the brush in white spirit or turpentine (see page 17). Then, with a vegetable oil soap or similar, tease out the paint residue under running warm (not hot) water. When thoroughly cleaned, leave the brush to dry naturally on its side, then store upright, with the bristles pointing upwards, in an open container. Do not store brushes until they are completely dry, otherwise the water will rot the hair in the ferrule of the brush.

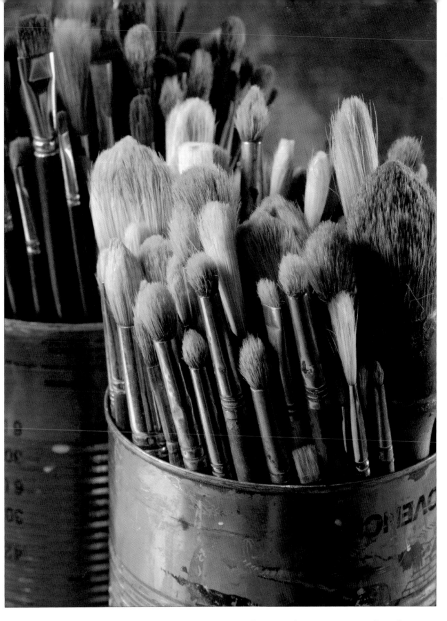

Any large container can be used to store your brushes. I keep mine in two large olive oil tins.

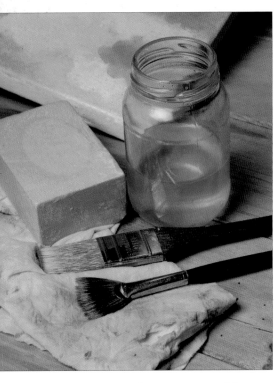

The essential items you need for cleaning your brushes – a lint-free rag or cloth, white spirit or turpentine substitute in a jar, and a bar of vegetable oil soap.

Remove excess paint from your brush by rubbing it on a rag or cloth before cleaning, and before changing to a new colour during a painting.

Remember to clean your palette with a rag or cloth when you have finished painting, and also before changing colour during a painting.

Canvases

Artists have been known to paint on copper de-greased and primed with oil primer, linoleum, sized paper, photographic paper, glass and perspex. However, the surface traditionally favoured by oil painters is canvas. A canvas is the general name given to a fabric support, either mounted on a stretcher or glued to a board, which requires sizing and priming before use (see page 16). For the beginner, I would recommend purchasing pre-stretched canvases or canvas boards (oil boards) that have been acrylic primed and are suitable for use with both oils and acrylics.

Linen

Linen is a strong, durable, stable and subtle fabric support. It has a natural woven finish and is available in many weaves and grades, including superfine. The fibre length (staple) is longer than that of cotton – choose a close weave where the warp (vertical) and weft (horizontal) threads are equal in tensile strength. When stretching, the warp length of the canvas should be pulled across the shortest distance, while the weft thread should be pulled over the longer distance as it will shrink less when sized. This shrinkage will depend on the type of linen: lightweight, closely woven fabric shrinks less than heavier, loosely woven linen. Both linen and cotton are hygroscopic compared with synthetic fabrics like polyester – they tend to absorb moisture from the air and therefore expand and contract readily with changes in atmospheric temperature and humidity.

Cotton

Cotton is cheaper than linen and generally not as strong. Heavier weights perform better; lighter, looser weaves are too unstable. Once sized and primed, cotton is more susceptible to atmospheric change than linen.

Hemp, jute and burlap

These are coarse, heavy, short-fibred and cheap. They are highly absorbent and brittle and deteriorate quickly.

Synthetic fabrics

Some manufacturers are developing synthetic fabrics or mixtures of natural and synthetic fibres for use by artists. Synthetic fabrics are less susceptible to atmospheric change. Polyester seems to be the best and has been used by picture restorers to reline paintings. It is stable and retains tension. Fabrics are available which mix natural fibres with polyester fibres, but these suffer from the problem of fluctuating tension.

A variety of pre-stretched canvases, canvas rolls and canvas boards, all sized and acrylic primed ready for use.

Oil papers and oil boards

Oil papers and pads are widely available. The paper has a thick, canvas-textured surface which is oil resistant with a slightly slippery surface. Oil board has a similar surface to oil paper but with more 'tooth' (texture) and a slightly more absorbent surface. It is essentially stable but prone to warping as the board is vulnerable to damp conditions.

Boards and panels

Hardboard, plywood, millboard, MDF and mountcard – all, if properly sized and primed, will provide satisfactory surfaces for oil paint.

Oil papers and pads are ideal for sketching and working outdoors.

Preparing canvases: sizes and grounds

A board or canvas support should be 'sized' before the application of the primer. It is possible to apply acrylic primer to canvas without sizing, but the primer will strike through to the back of the canvas and need several coats. Sizing reduces the absorbency of the support, which otherwise will leach out the binder in the primer (see page 17), thereby reducing the brilliance of the paint and rotting the canvas. A ground (see page 25) is then applied on top (priming), providing a uniform base on which to paint and offering further protection for the canvas. All priming and sizing is best done on a warm, dry day.

Acrylic primer should always be sized with acrylic size, and oil-based primer with an aqueous size such as rabbit size. The recipe for traditional rabbit size is provided opposite; acrylic size is available ready-made, though PVA glue diluted one part to five parts water can also be used.

Oil-based primers

Titanium white pigment in oil provides a traditional base for oil painting, and some artists consider it to be a better ground than acrylic primer for oils. Stir the primer thoroughly and apply two thin coats using a household paintbrush. Oil-based household wood primer can be used instead of the finer milled artists' primer. Wait at least a week, preferably two, before painting on the primed canvas.

Acrylic size and primers

Acrylic primers offer a good alternative to oil-based primers, and can be used as a base for oils (though oil-based primers cannot be used as a base for acrylic paint). They are fast drying and can be less susceptible to attack from mould. However, as a relatively new material we have no way of knowing how they will endure. Early indications suggest that acrylic becomes brittle with age, unlike oil which retains its flexibility.

Artists' quality acrylic primer is usually finely milled for greater opacity, though a good substitute is again household acrylic wood primer. Again, apply two thin coats.

Gesso

For oil painting on panel, the most commonly used ground is gesso – an inert white pigment such as chalk, whiting or plaster of Paris, and an aqueous binder such as casein or animal glue. Ready-made gesso, including acrylic gesso, is easily available. It is more absorbent than ordinary primer and leaves a matt finish, but it is less flexible and so is best applied to a rigid support such as board or plywood. This should first be sized, and a scrap piece of muslin, cotton or canvas glued to it to provide a good 'tooth'.

Making rabbit size

The most commonly used size is rabbit skin glue, bought as a granular powder or in solid leaves. This is mixed with water (one part glue to twelve parts water) which is then heated until the granules or leaves dissolve, and then allowed to cool. Once set, a jelly should form that yields to gentle pressure from your hand. This is then reheated, but not boiled, and the glue applied to the fabric while still hot. The first coat should be left to dry naturally before a second coat is applied. If your support is mounted on a stretcher, use a blunt table knife to release the back of the canvas from the flat face of the stretcher.

Household gelatine can be used instead of rabbit skin glue, following the instructions on the packet.

Making traditional gesso

Follow the instructions for size given above, adding refined whiting or Bologna chalk until you achieve the consistency of single cream. The addition of a little titanium white pigment will increase the brightness. Paint successive warm layers on to your prepared board, allowing each layer to remain damp in between applications. Do this as many times as you wish – up to seven coats is normal. When dry to the touch, remove any brush marks using a damp cloth and a circular action. Finish with a wet-and-dry emery cloth, pumice powder or cuttlefish bone for an ivory-like appearance. If you wish to reduce the absorbency of the gesso panel, size when bone dry with Dammar varnish thinned with turpentine in the ratio of one to one. Alternatively, rub in some linseed oil.

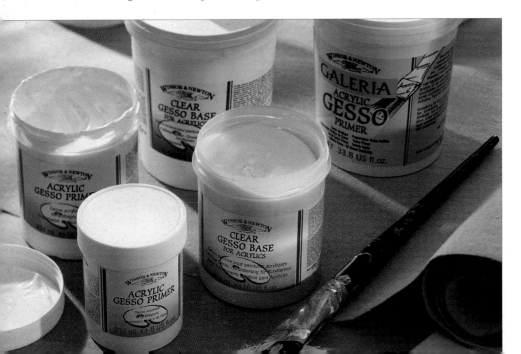

A selection of commercially available acrylic primers.

Mediums

Mediums are oils and resin varnishes used in the preparation of oil paints, and which are added to the paints during use to change their character.

Linseed oil

Cold-pressed linseed oil is used as a binder in the manufacture of oil paint and is of the best quality. Refined linseed oil is a modern industrial product which is often bleached to impart a paler colour. It will dry slightly more quickly, in three to four days, than cold-pressed linseed oil, but produces a less durable glossy paint.

Stand oil

Although cold-pressed and refined linseed oils are the binders for oil paint, their prolonged drying times make them less suitable as mediums for oil painting. Modern stand oil is linseed oil that has been heated in a vacuum. The result is a viscous oil that dries quickly, is flexible and brushes out smoothly. Add a little stand oil to your paint to maintain the flexibility of the oil-paint film and prevent over-thinning with solvent (see below).

Sun-thickened oil

A pale, viscous oil that is pre-polymerised by exposing it to sunlight. The best method is to pour cold-pressed linseed oil into a shallow tray and cover it with a sheet of glass supported by a pad of cork at each corner to allow ventilation. Agitate the oil every other day to prevent a skin from forming. After four weeks the oil will be paler and have the consistency of honey. The resultant oil speeds drying time and facilitates glazing, and the paint will have a smoother, more enamel-like quality.

Solvents

Solvents are used for thinning oil paint, resin varnishes and balsams, and for cleaning brushes and palettes.

Turpentine

Turpentine is ideal as a solvent for thinning linseed-oil-based mediums, resin varnishes and balsams, though too much turpentine in the paint may affect the adhesion of the oil-paint films and rob the paint of its lustre. This effect can be reduced by adding an equal quantity of stand oil. The best grade of turpentine to use is rectified or double rectified. Distilled is also acceptable. Do not use gum turpentine as it leaves a sticky residue which interferes with the paint, and the resultant oil films will dry and crack. If you dislike the pronounced odour of turpentine, a low-odour alternative is available known as Sansodor.

White spirit

White spirit is an industrial petroleum solvent best used for cleaning brushes and palettes. It evaporates faster and less evenly than turpentine, but can be made more stable as a paint thinner by mixing a little stand oil with it.

Applying a mix of paint and stand oil. The oil improves the workability of the paint and makes it easier to apply.

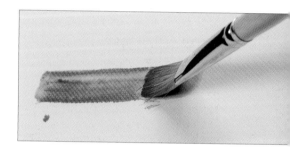

Thinning the paint with a little turpentine makes it more fluid and easier to draw with.

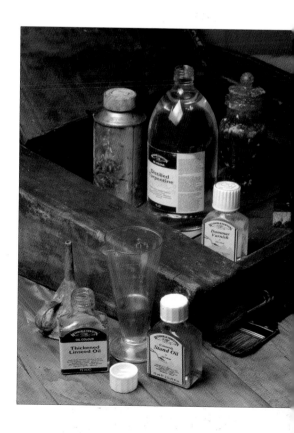

A range of mediums and solvents which can be added to oil paint to dilute it, improve its drying time and make it generally more workable.

Varnish

Varnishes can be used as a painting medium or applied to finished paintings to protect them, but their use is directed entirely by personal taste. They can refresh a painting and enhance the colours, though some artists find that the glossy finish makes it difficult to light. Matt varnishes are available, however, that overcome this problem.

Resin varnish

The most useful resin varnish is Dammar. It is clear, brittle and durable and is obtainable as crystals which must be dissolved in turpentine (100g of crystals in 300ml of turpentine), and as a commercially prepared varnish.

For an excellent painting and glazing medium, stir together 50ml of Dammar varnish and 50ml of stand oil, then add 200ml of rectified or distilled turpentine. This medium is very flexible; reducing the turpentine will make it more viscous.

Retouching varnish

Retouching varnish is ideal as a temporary varnish for recently completed paintings as it is easily removed. It can also be painted over, making it useful for reviving dull areas of paint. It consists of a thin solution of Dammar in ethyl alcohol, and is available commercially. Some retouching varnishes are acrylic-resin based. They should be used sparingly and not as an additive to paint.

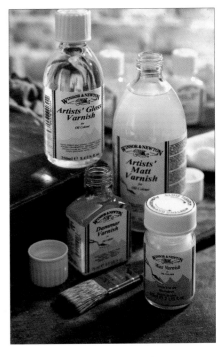

A selection of commercially available varnishes.

Easels

The best easels are traditionally made from hardwoods such as beech, mahogany and oak. Lightweight easels are often made of aluminium. Unless you have plenty of room, a standard radial easel or H-frame studio easel is out of the question. A portable, lightweight easel together with paint box and carrying strap are essential for the landscape painter. As a beginner, choose a table-top easel that takes up little room and is easily stored. You may need a drawing board as well, easily made from 8mm plywood.

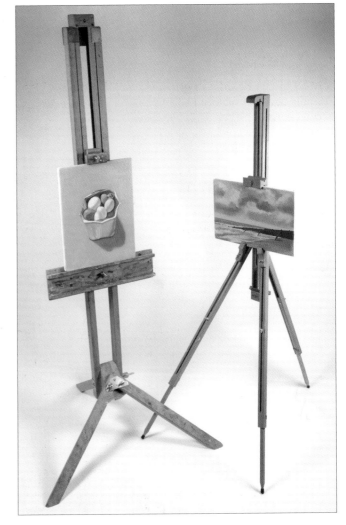

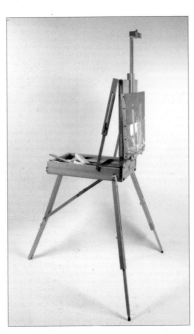

The left-hand easel shown opposite is a folding easel with a carrying handle and box for storing paints. In the centre is a radial easel suitable for studio work. It will hold paintings up to 170cm (67in) wide. The easel on the right is a smaller, lightweight folding easel.

Palettes

Palettes provide a surface on which to keep your paints while you are painting; arrange them around the outside, with a space in the middle that you can use for preparing mixes. Traditionally, palettes are wooden, and either kidney shaped or rectangular. White, grey and clear palettes are also available, either plastic, glass or porcelain. With a clear plastic or glass palette on a table-top, coloured papers can be inserted underneath to help you match colours. Some artists maintain that a white palette, being consistent with the white ground of the support, makes colour judgements easier. This, of course, becomes less of an advantage once the painting is begun. With practice, you will learn to judge how a colour mixed on the palette will transfer to canvas, despite the differences between them in tone and warmth. This is, after all, how Cézanne, Manet, Chardin, Rubens and Rembrandt worked, to name but a few!

Dippers

These are small metal containers, sometimes with screw-top lids, that are used for turpentine and oil. They have a clip underneath, enabling them to be attached to the edge of your palette. Small tomato purée tins or similar can be used instead, though be sure to rub down any sharp edges first.

A palette provides somewhere to keep your paints while you are painting, and a surface for mixing on.

Rags and cloths

Use lint-free cotton rags, cloths, paper towels or wipes for cleaning your paintbrushes, palette knives, and so on, and for removing excess paint from your painting.

Cuttlefish

A small piece of cuttlefish provides a mildly abrasive surface for rubbing down canvases or panels. It can also be used to give a thick, smooth layer of paint a 'tooth' for working over.

Barrier cream

Useful for protecting your hands from white spirit, turpentine and toxic pigments.

A selection of the items listed above.

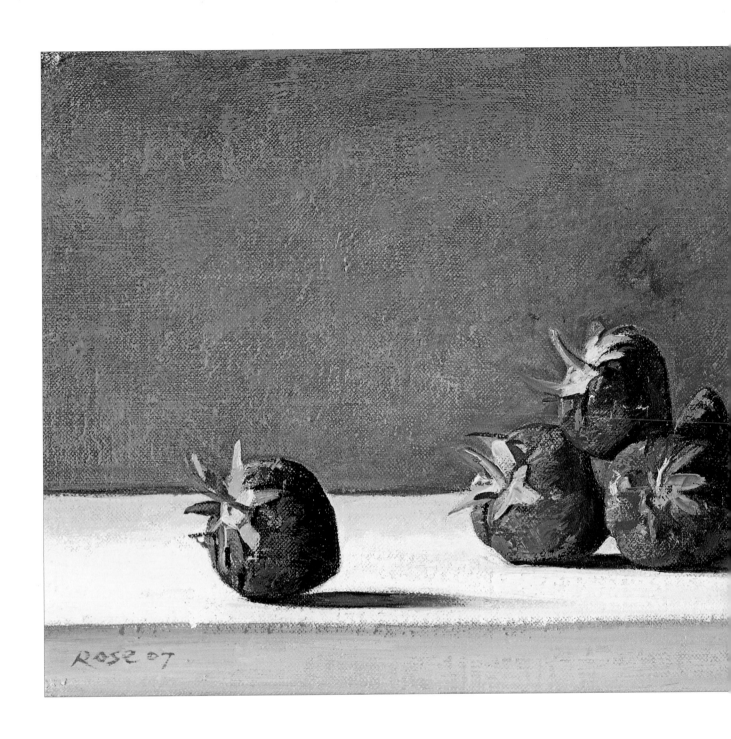

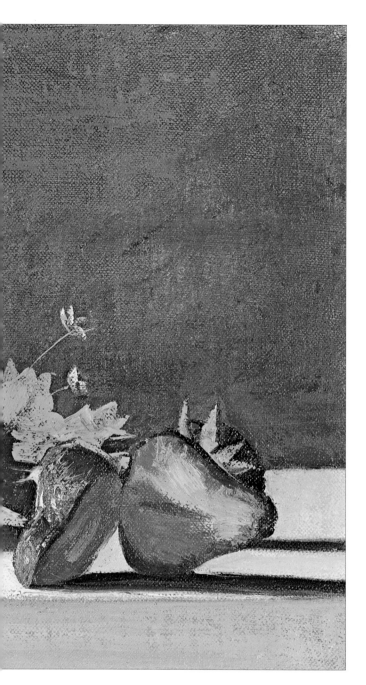

Strawberries

25 x 15cm (9¾ x 6in)

Red and green always make a strong impact. Here I try to evoke the texture of the strawberries rather than paint the pattern of the seeds. The crown of leaves provides a contrast of colour and texture. The pyramid of strawberries echoes the shape of the individual fruit, and the cut strawberry provides a change of colour and form.

Colour

An understanding of colour and how it works is an essential ingredient in the creation of a successful painting. As you gain experience, colour choices will become second nature, but when you are first starting out it is useful to have some knowledge of which colours work well together, and how to vary a colour to achieve areas of light and shade.

Mixing a tertiary colour, in this case from cadmium scarlet, lemon yellow and French ultramarine.

Basic colour theory

Basic colour theory is best explained by the colour wheel, an example of which is shown below. The 'spokes' of the colour wheel each contain a different colour: the three primary colours, red, blue and yellow, which cannot be mixed from any other colour, and various mixtures of each pair of these (the secondary colours) placed in between. So, for example, as you move around the circle from blue to red via the violets, the relative amount of red in the mix gradually increases and the amount of blue decreases. Similarly, between red and yellow there is a range of oranges in which the proportion of yellow gradually increases, then from yellow to blue are the greens. Complementary colours are those colours that face each other on the colour wheel, for example blue and orange, and red and green. In painting, complementary colours are known to work well together, a fact which the Impressionists used to stunning effect.

In addition to the primary and secondary colours are the tertiary colours, or earth tones – the browns and greys. These are created by mixing two complementary colours or, in relation to the colour wheel, mixing a primary colour with a secondary mixed from the remaining two primaries. Blue and orange makes olive greens, yellow and violet result in browns, and red and green together create tans and russets.

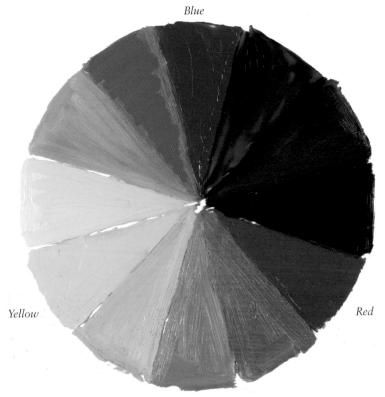

Blue

Yellow

Red

The colour wheel.

Colour can be defined in terms of various characteristics:

Value:
this refers to the tonal value of a colour, in other words whether it is a **tint** (has white added to it) or a **shade** (with black added to it).

Hue:
the basic attribute of a colour, in other words whether it is red, blue, green, etc. It does not include black, white or greys.

Saturation:
the degree to which a colour possesses **hue**, for example red, yellow and blue have high levels of saturation, whereas browns and greys are low in saturation.

Temperature:
Colours can be classed as warm or cool; warm colours are closer to red, whereas cool colours are nearer to blue.

Mixing colours

Mixing colours relies partly on a good basic knowledge of colour theory, and partly on intuition. To ensure success, try never to mix more than three colours, and mix colours incrementally – a little at a time. Bear in mind the qualities of the paint (see pages 10–11); for example Prussian blue has a powerful tinting strength, whereas cobalt blue is weaker. Titanium white will lend opacity to a mix; earth colours will dominate. Mix colours carefully to achieve the desired effect, then apply them with confidence.

Colour can be mixed dynamically, in other words amalgamated together on the palette and applied with a brush or palette knife. Colour can also be mixed together on the surface of the support to give a 'broken' colour.

A **lean** mix consists of paint mixed with more turpentine than oil, or with a fast-drying oil.

Fat oil paint is paint straight from the tube; a fat mix has even more oil added to it.

You might want to use a palette knife to mix paint on a palette when you need to mix a lot of colour and have the colours thoroughly amalgamated. Use a brush when you want to adjust a colour incrementally or when the rhythm of the act of painting demands continuous brush strokes.

Mix pigments together on a canvas when you desire a broken area of colour or the transition of one colour to another. The use of a palette knife will give a broader, smooth sweep of colour than a brush.

Colour can also be achieved 'optically' by overlaying colour through glazing or scumbling (see pages 28–31). By this method, a second colour is laid over a first colour so that the viewer sees a third colour, for example red laid over blue would make an optical violet. Another optical method would be to juxtapose two opposing colours (colours that lie opposite each other on the colour wheel), for example yellow and blue, to give the illusion of a third colour, in this case green.

Varying tone

The tonal value of a colour is defined as the relative amount of black or white added to it. In practice, however, a darker shade can be achieved by adding a dark blue rather than black, as shown in the example below.

Varying the tone of cerulean blue (in the centre) by adding progressively more titanium white towards the right, and Prussian blue towards the left.

Your basic colour palette

A good basic colour palette to start off with would consist of the colours shown below. Using fewer colours is helpful to the beginner as it forces you to mix colour, familiarising you with the potential of each pigment. It also helps create unity in a painting, ensuring you seek out equivalent colours within the picture. Having said this, it is just as well to know that masters of colour harmony such as Cézanne and the young Titian used fifteen to eighteen separate pigments.

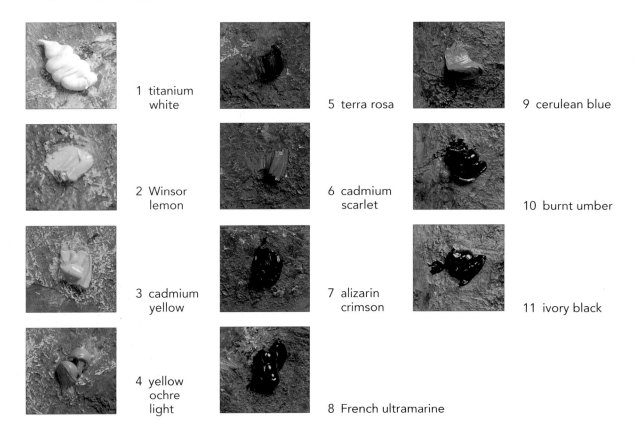

1 titanium white

2 Winsor lemon

3 cadmium yellow

4 yellow ochre light

5 terra rosa

6 cadmium scarlet

7 alizarin crimson

8 French ultramarine

9 cerulean blue

10 burnt umber

11 ivory black

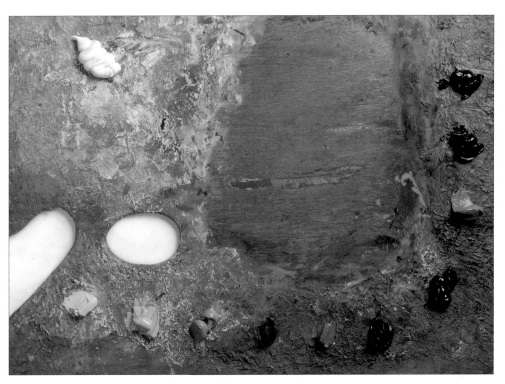

This is a basic colour palette, made up from the most commonly used colours shown on page 11. It is designed so that each primary colour has a warm and a cool cast, and to provide a good balance of saturated and earth colours. For each primary colour there is an opaque and a semi-transparent pigment.

Arrange the colours in the order indicated above around the outside of your palette every time you paint, so that you get to know where each colour is located. Each demonstration (pages 36–63) features a selection of colours from this palette.

Grounds

The white or off-white ground of the primer coat has been the surface of choice for oil painters for many years. This has its origins in egg tempera painting on gesso panels (prevalent in the Middle Ages before being replaced by oil painting) and fresco painting on lime plaster. The development of coloured grounds during the Renaissance reflected the increasing desire for more colouristic and tonal effects. Red, yellow ochre light, beige, earth green, umber, grey and, in the case of Tintoretto and Goya, even black grounds were used over the surface of the primed support. Often, rather than a double ground, the white priming was itself coloured with pigment before application.

A coloured ground can unify a painting by providing a common value and colour to subsequent layers of paint. It can act as a foil to warm or cool colours, depending on the warm/cool bias of the ground. The ground will also affect the tonal value of the painting, making it darker, and is an essential part of chiaroscuro ('light and dark') painting, as in the work of Caravaggio and Rembrandt.

If you use oil paint in the preparation of a coloured ground, you must wait at least two weeks until it is perfectly dry to avoid lifting it when you start to paint. Acrylic primer followed by acrylic paint (watered down and applied with either a large paintbrush or a lint-free rag) as a quick-drying ground will not interfere with subsequent oil layers.

In my own painting, I tend to use three different types of background, which are shown below. In general, what colour you use depends on the tone of your painting – use a warm background wash to give a paint lustre. If your painting is predominantly cool, a warm background wash will complement it.

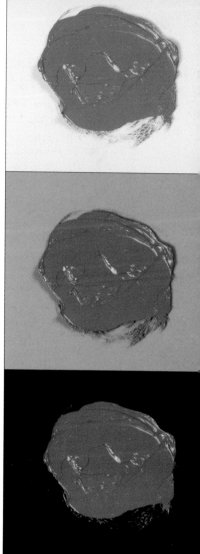

The images opposite demonstrate how the appearance of a colour, in this case cadmium scarlet, can vary depending on the colour of the background.

A mix of ivory black and titanium white heightens warm colours and gives a silvery, high-key appearance to a painting. It is ideal for paintings in which greys predominate, for example winter landscapes, or in which warm colours may provide only an accent, such as in portraiture, or a neutral foil to high-keyed colours.

Raw sienna, burnt sienna and titanium white produce a beige to warm brown which heightens cool colours and retains a high key. Both this and the previous ground will help produce mid tones and optical greys by scumbling over certain colours (see page 28). This ground is useful for all types of painting, including landscapes, still life and figure painting.

Burnt sienna and burnt umber produce a darker, warm ground. Useful for predominantly low-key pictures heightened by dramatic light areas of dense pigment.

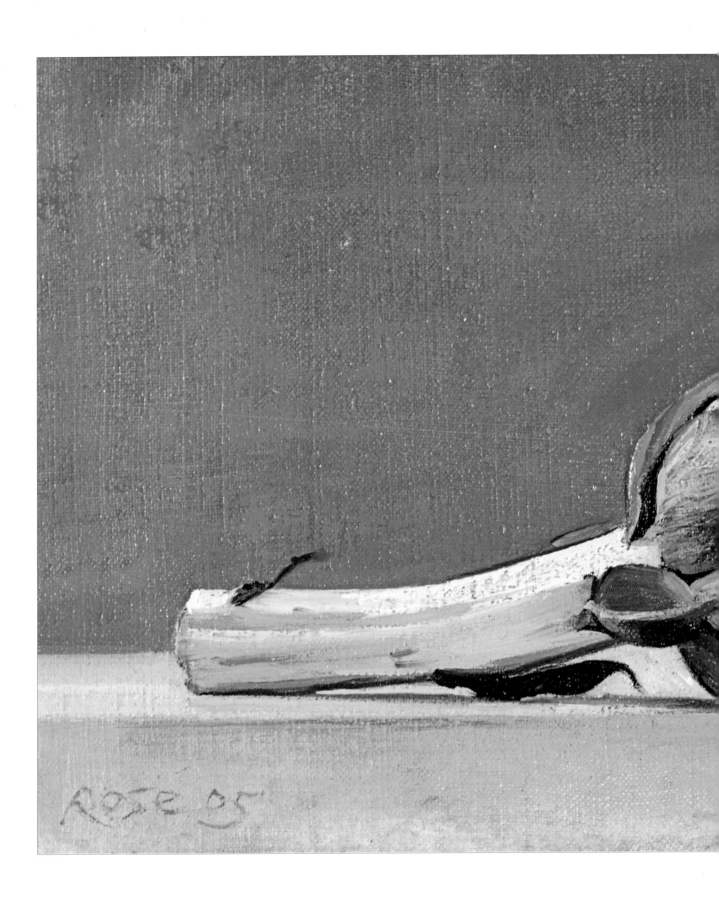

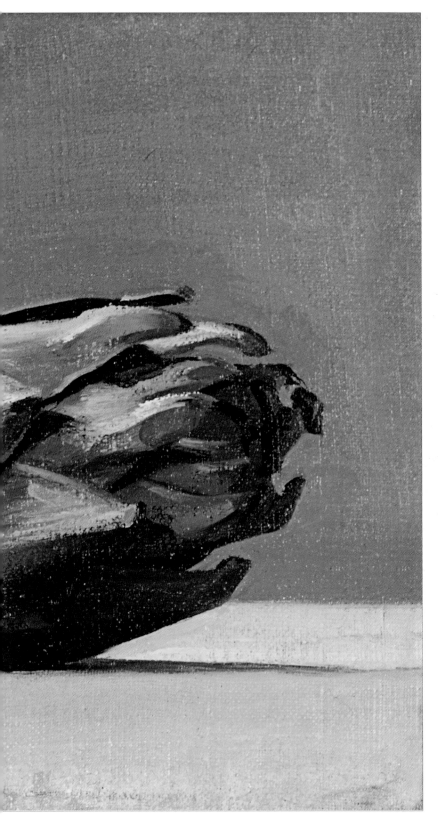

Artichoke
25 x 20cm (9¾ x 7¾in)

In this picture a violet-blue background complements the green and harmonises with the red-violet of the artichoke. The plain background also acts as a foil to the complexity of the subject. There is a play of textures between the fibrous petals and the thick stem, achieved by the manipulation of coarse and soft brushes of different sizes together with dry and viscous paint.

Techniques

The techniques of paint handling are the signature of the artist and are inseparable from the style of their work. They are as much the result of an emotional response as a practical solution to painting, and are in a state of constant development throughout an artist's life. Avoid the affectation of mark making and handling if it doesn't seem to fit with your way of working, otherwise the result will be false and banal.

As a beginner, however, you need to be aware of the range of techniques available in order to equip yourself properly with the necessary skills and knowledge to develop as an artist. For this reason, I have included below some of the painting techniques commonly used in oil painting which, once mastered, will provide a firm basis from which your own, unique style of painting can evolve.

Dry brushing

Applying semi-dry paint gently over the surface to pick up the high points and ridges of the underlying paint or canvas, leaving a broken or friable mark. The underlying paint needs to be dry. Use this technique to attract the eye to an area of a painting and make it advance. See the artichoke stem on page 26 and the strawberries on pages 20–21.

Scumbling

Working solid paint over another colour, barely covering it. Scumbling works well over a textured surface. Use opaque or semi-opaque pigments. Good for subtle gradations and transitions of colour, for example light effects, clouds, sunlight and space around objects such as the tulip on page 35.

Sgraffito

Drawing into the paint with the end of a brush handle or stylus to remove paint or to correct mistakes. This technique can be used to draw in hair or ringlets at the edge of the head in a portrait, or perhaps the rigging of a boat or the roots of a vegetable. You might use this technique to draw into the paint revealing an underlying colour, or simply for its own sake to enliven an area.

Hatching

Parallel brush marks. Cross hatching is two sets of parallel brush marks laid in opposing directions. This technique can be employed to paint grasses or fabric, or anything that requires a shimmering surface. It can be used to describe form, or to give weight or a sense of direction to an area.

Rubbing

Using your finger or a ball of lint-free cloth to blend colour on the canvas. Exercise caution when using toxic pigments. This will achieve a soft transition of colour or fading of colour. It can also be used to apply a glaze. Good for achieving brilliance of colour over a white surface when using semi-transparent colour, and also for atmospheric effects.

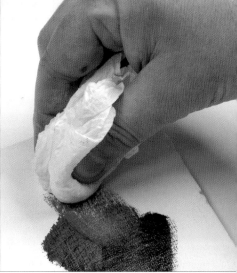

Splattering

Making random marks with fluid paint. The area covered can be controlled by using masking fluid. You could use this to convey force and chaos, such as crashing waves, snow, volcanic eruptions, etc., or for adding a random element to a painting.

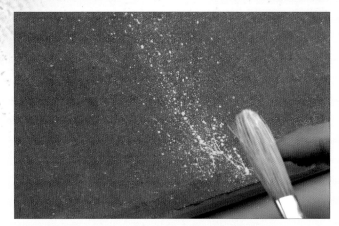

Pulling

This is achieved by pressing paper, blotting paper or a lint-free rag on to the paint surface and pulling it off, leaving a residue of paint. You might use this to remove excess paint or to create a semi-opaque, irregular surface.

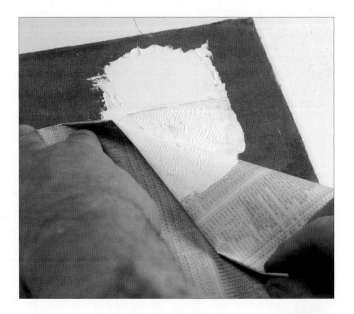

Scraping back

Laying in colour and then removing it using a palette knife, leaving a thin trace of paint. This technique is also used to remove an unsatisfactory section, or passage, of a painting either when dry or before it dries.

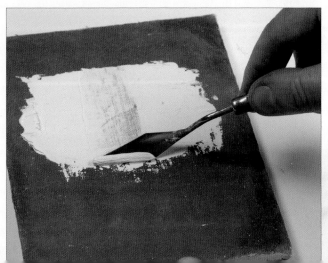

Dabbing or pressing

Applying a dab of colour with a brush, knife or wad of lint-free cloth. Use this to apply a pure piece of paint without transition or blending, where no gesture or movement is required, for example the light on the cherries on page 64.

Glazing

Applying translucent colour in a rich medium over existing colour. This technique can be used to modify a colour, to make a colour deeper or darker, or to make a further colour by applying it over another colour, for example a red glaze over blue underpaint will make violet.

Blending

The gentle mixing of colours on the canvas. Use a fanned brush for extra-soft blending. You might use this where soft transitions are needed, for example a piece of fabric, the shell of an egg, or the face of a child.

Frotti

Applying a semi-opaque, medium-rich paint over an existing colour. Make sure that the frotti is sufficiently medium-rich using stand oil or similar oil, or varnish. It was frequently used by the old masters to apply a silk cravat or lace cuff over the neck or hand. This technique could be used to paint rolling waves in a seascape.

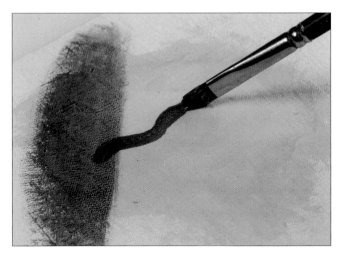

Using the brush

Most beginners use the brush like a pen or a chopstick, so that all movement is in the fingers. By holding the brush further towards the end of the handle it becomes an extension of the arm, and the whole movement of the arm can be brought into play. The lack of control that the beginner feels can be overcome by gently applying pressure to the tip of the brush and allowing the weight of the arm to drag the brush down. This is the paradox of attaining control by relinquishing it, much like cultivating the 'soft hands' of the golfer or tennis player.

Approaching the canvas from the right, left, above or below brings a dynamic to mark making, although the beginner will find it easier to drag the brush from a point at the top to the bottom. Holding the tip of a brush directly above the canvas or parallel to it will vary the mark even further.

Hold the brush towards the end of the handle for greater control and to prevent your hand from obscuring your work.

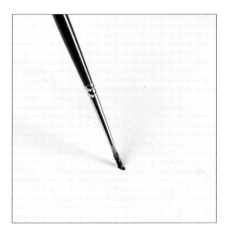

Use the tip of a round brush for applying highlights and pin-points of colour.

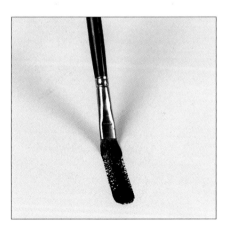

Use the full width of the brush for developing broad areas of space or form and for initial blocking in.

Use the edge of the brush for sharpening edges and drawing lines.

Use the tip for dabbing in colour, drawing lines and applying highlights.

For an undulating line that varies in width, start with the tip of the brush, twist the brush so it is flat, then twist on to the tip again.

Methods

Every artist develops their own unique method of producing a painting. Historically, however, four distinct methods have evolved, which are summarised below.

Pre-mixed tone technique

From three to seven tones are pre-mixed from each colour and white. Forms within the painting are modelled systematically with these pre-mixed tones, regardless of their perceived colour and tonal values. This approach is similar to the pre-mixed colour method of fresco painting and can be seen in early Renaissance painting and icon painting. It also provided a formula for history and portrait painters and can be seen in the work of Hogarth and Reynolds in the eighteenth century.

Staged painting

A staged painting (demonstrated below) is built up in a series of clearly defined stages, sometimes over several days or weeks. The first stage is the drawing stage, in which the outlines of the main elements are sketched in. The first layers of paint are then applied using extra lean monochrome or part-coloured mixes to define the main areas of light and dark. This is known as underpainting. The main body colours are then applied using lean mixes, followed by the first glazes. More layers of body colour are added using thickly applied paint in which the brush and palette knife marks are still visible, a method known as impasto. This is followed by further glazes. The painting is eventually finished by strengthening colours and adding accents where necessary, and strengthening and defining any ambiguities in forms or spaces until the painter feels there is no further work to do.

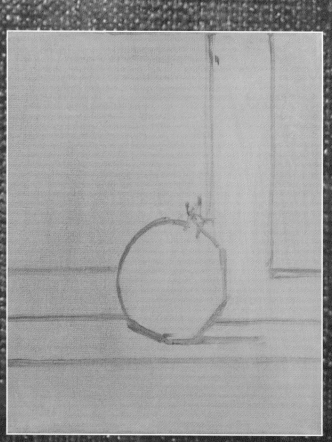

Initial drawing in with a sympathetic colour on a toned background of raw sienna and burnt sienna.

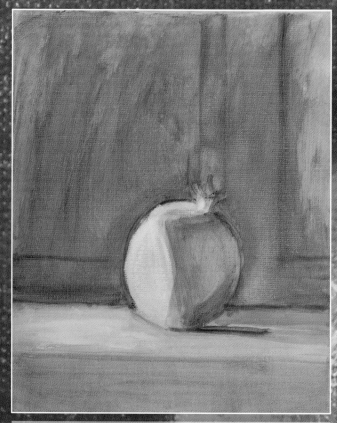

Monochrome underpainting in black and white to develop areas of light and dark.

Alla prima

A more immediate method than staged painting, though not necessarily completed in a single sitting. The main elements are drawn in, as in staged painting, then there is an optional underpainting stage followed by the application of several layers of body colour, beginning with lean mixes and finishing with impasto. Unlike staged painting, in alla prima each mark contributes to the final image without obscuring the preceding stages. Glazing is optional prior to finishing.

Fa presto

Similar to alla prima, but uses a dark ground, and mass, form, colour and light are all dealt with simultaneously in one sitting.

Direct painting

This is a modern form of alla prima, in which all the elements are developed in one sitting without any preliminary work and without any further applications of glazes or body colour.

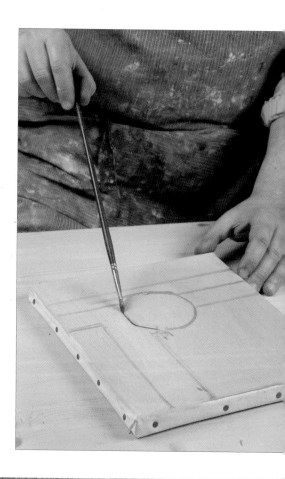

Use a good brush with a reasonable point for drawing, and thinned paint in a colour that complements the finished painting. Sketch the outlines of the main elements in the composition, positioning them centrally, by eye, on the canvas. Hold the brush at the end of the handle (see page 31) and use light strokes.

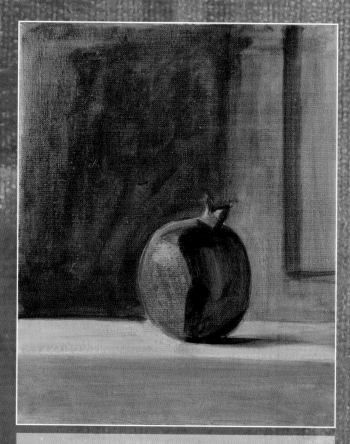

Initial laying in of body colours using lean mixes.

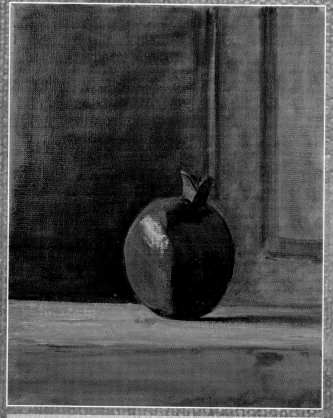

Further body colours using impasto, followed by glazes.

Summary

As a rule of thumb, don't fixate on one element of a picture while painting. Move from one part to another, working over the whole picture to develop context and the overall impression of the painting. Begin with the larger, dominant masses and spaces, either starting with the dark areas on a light ground or light areas on a dark ground. Some artists, for example Manet, began by eliminating the middle tones; others, such as Caravaggio, painted the extremes of light and dark whereas Van Dyck started with the middle tones and added the dark and light tones as accents. You will find artists to support all different methods and procedures.

Observe your subject carefully as you paint and react to what you see. Vary the proportions of the different colours in your mixes accordingly, and gradually introduce more colours as your picture develops. Look for areas of similar colour to unify the painting and remember that colour depends on context (see page 25), so do not make subtle judgements until you have established the broader picture. You will probably need to modify contrasts as your painting develops.

Concerning the structure of oil paint, try to work fat (oil-rich) paint over lean (diluted or thin) paint so that successive layers are more flexible than the underlying paint. This is to prevent the paint from cracking.

It is common for beginners to lack confidence in their use of darker tones, often diluting them with white. This, and a tendency to mix too many colours together resulting in turgid hues, give rise to paintings that lack fullness in terms of tone and colour. A failure to keep the brightest colours in reserve means your pictures will have no opportunity for climax and will therefore lack impact. Lay light against dark, warm against cool, saturated against broken colours. These are the contrasts that can be employed to make your pictures delight the eye. The simple maxim of warm light/cool shadows, cool light/warm shadows underpins much of painting from life.

Strengthen the edge of an object by intensifying the background behind it. Place the top of a flat brush against the edge and drag the paint away from it. Apply opaque colour to the petals using wet-in-wet; for the semi-opaque shadows use fluid paint.

Accentuate contrasts as your painting develops, and finish by strengthening shadows and adding highlights where necessary.

Introduce subtle variations in colour as your painting progresses by varying the relative proportions of the colours in your mixes. For the stem and leaves use semi-impasto, and apply the paint using long strokes and a soft brush.

Stippling using a coarse brush and semi-opaque paint will allow the ground to show through, giving movement and variation in an otherwise bland area.

Minute observations, such as the colours reflected in a shiny surface, will add richness and realism to your work. For opaque light, work impasto using a soft brush.

Begin the background by working a thin layer of paint around the main elements to define the composition. The roundness of the glass flask is achieved by crisp, directional modelling using a soft brush.

Create a diffuse edge around the shadows by softening it with your finger or by painting wet-in-wet with a soft brush.

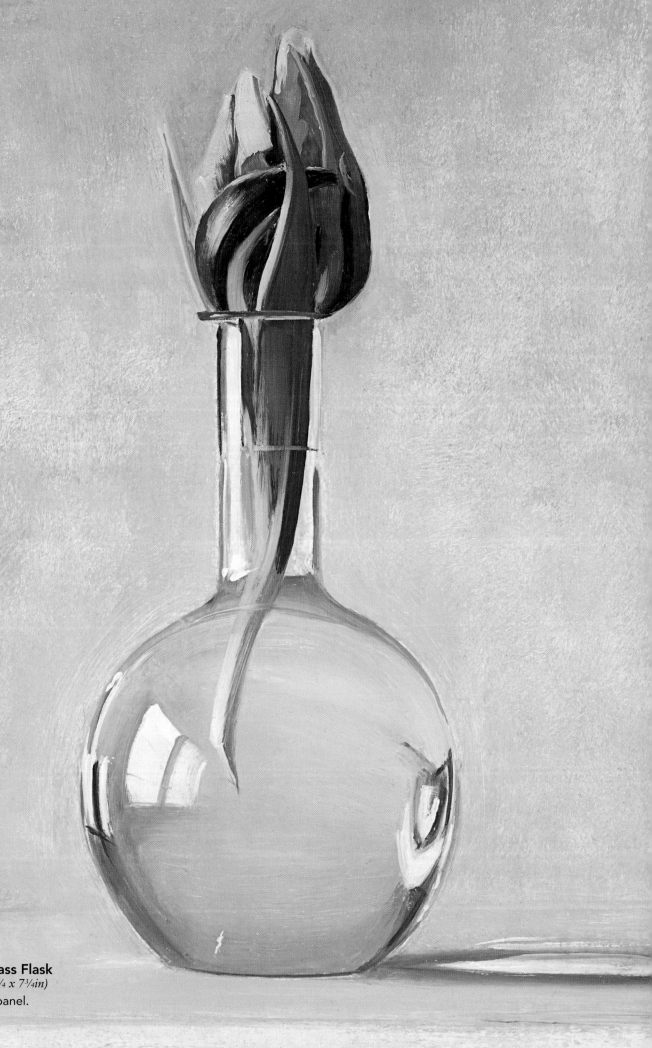

Tulip in a Glass Flask
30 x 20cm (11¾ x 7¾in)
Oil on gesso panel.

Demonstrations

Here are three projects designed to build up your colour palette incrementally and your confidence in handling the paints. The subjects of the first two demonstrations are household objects that are easily available: the first project, 'Eggs', uses a limited palette, and the second, 'Bottles', uses an extended palette that includes saturated primary and secondary colours, and opaque and semi-transparent pigments. The third painting, 'Seascape', is from a simple drawing I made of a beach and uses an extended palette.

 All of the materials and equipment you need are listed at the beginning of each project. Try to complete the paintings in five to six hours. Do not worry too much about the drawing, particularly the ellipses. Remember that these are painting projects, not exercises in linear drawing!

 Always begin by laying out all the colours you will need on a palette of adequate size. If you are using a medium, for example turpentine and stand oil, make a film of medium on the palette and bring the paint to it, rather than dipping a loaded brush into the medium. Keep your brushes clean, and work near a north-facing window if possible as the light is more constant.

Red Lettuce
26 x 19cm (10¼ x 7½in)
Oil on panel.

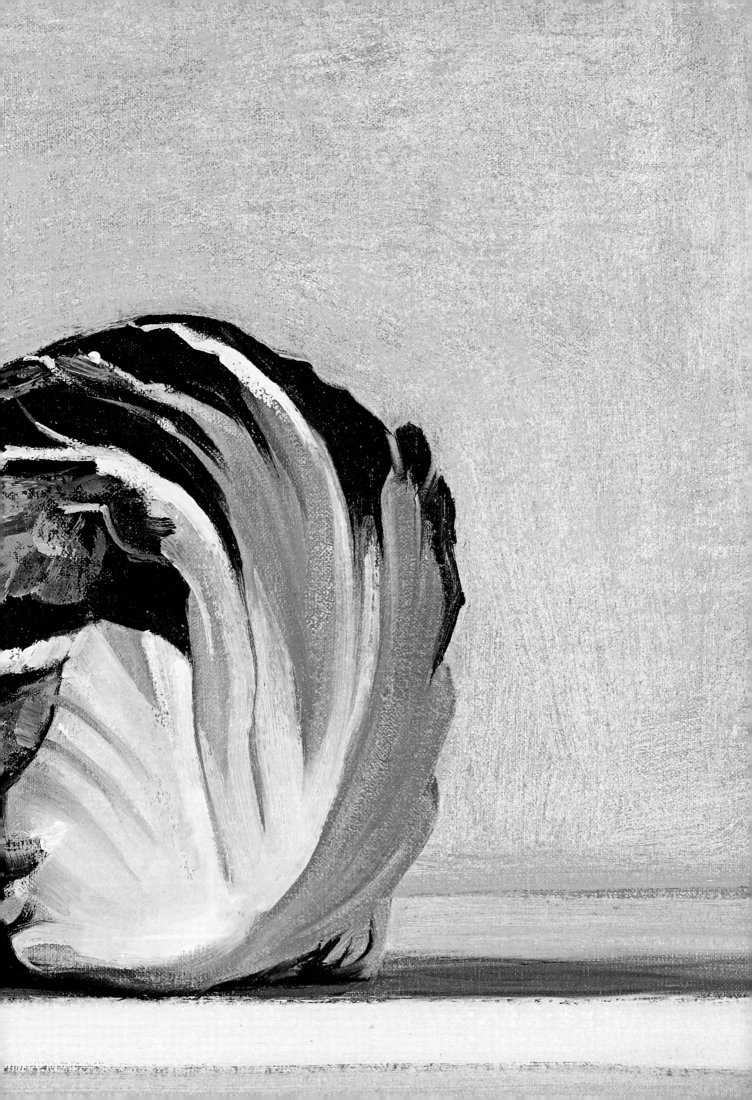

Eggs

This first demonstration is designed to familiarise you with mixing and developing the potential of the earth colours. No primary colours are included, and the subject matter is easy to obtain and offers a range of subtle colour variations.

The composition.

1 Ground: lay on a thin application of burnt sienna acrylic paint and allow to dry.

You will need

Primed canvas or board, 25 x 30cm (9¾ x 11¾in)

Paintbrushes: No. 4 filbert, Nos 4, 6 and 10 soft round

Burnt sienna acrylic paint

Turpentine, stand oil, white spirit (for cleaning brushes), rags and palette

Colours (clockwise from left):
ivory black, burnt umber, burnt sienna, terra rosa, gold ochre, yellow ochre light, titanium white, zinc white

2 Composition: using a sympathetic colour, draw in the subject with a No. 4 filbert brush or similar.

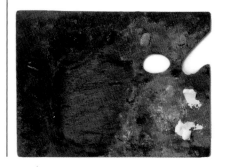

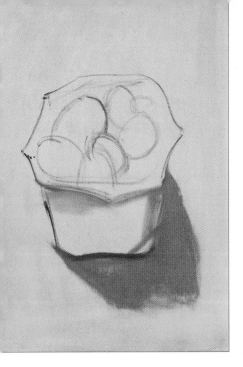

3 Dark values: for the shadow cast by the aluminium container, and for the shadows below the lip and down the right-hand side of the container, mix ivory black, yellow ochre light and burnt umber to make a soft, dark green. Apply the paint with a No. 6 round brush, thinly so as not to obscure the texture of the canvas.

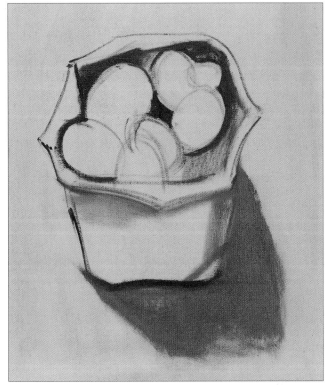

4 Mix ivory black, burnt umber and a little zinc white to make a warm grey for the inside of the container.

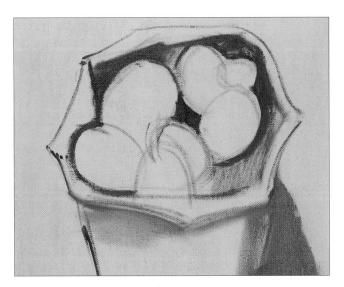

5 Define the outlines of the eggs by applying a warm shadow of the above mix, without the zinc white but adding a little gold ochre instead.

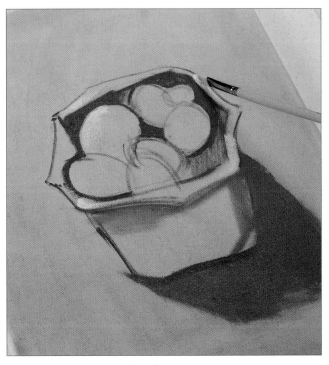

6 Light values: apply titanium white with a firm No. 4 filbert brush, placing extreme lights on the rim of the container and on the high point of the principal eggs.

7 Background: having established the extremes of dark and light, mix a cool green of zinc white, ivory black and yellow ochre light. Apply with a No. 10 round brush unevenly so as to allow the ground to show through. Using this mix, apply paint to the front of the container for the reflection. Use a little more yellow ochre light to advance the foreground.

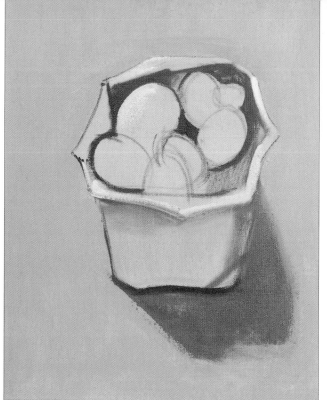

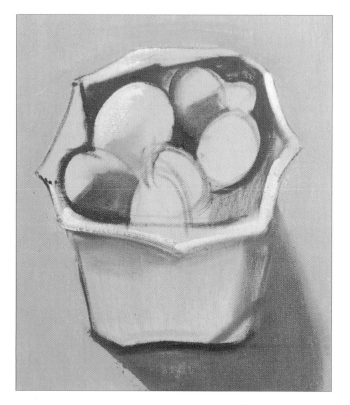

8 Eggs: using a No. 4 filbert brush and a fairly thin mix of burnt sienna, burnt umber and a little yellow ochre light, put in the main colour of the two brown eggs. Blend the edges into the dark shadow, keeping them crisp where they receive light.

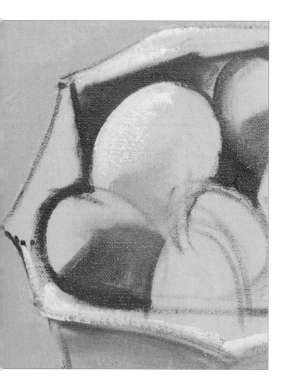

9 Apply a light touch of this brown to the goose egg where it receives colour from the adjacent brown egg.

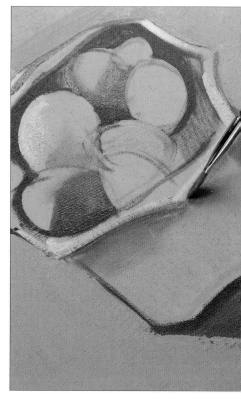

10 Add a blue-grey value to the pale blue egg by mixing ivory black and zinc white. For the colder violet shadows under the rim and along the right-hand side of the container, add a light terra rosa to this mix.

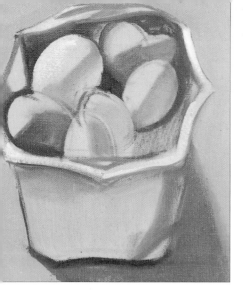

11 Use a leaner mix of this violet-grey for the shadows on the white eggs. Add a little more terra rosa for the pinker duck egg in the foreground. For the pale chicken egg on the right, use a mix of burnt umber, yellow ochre light and zinc white. Add a little ivory black to this for the small quail's egg.

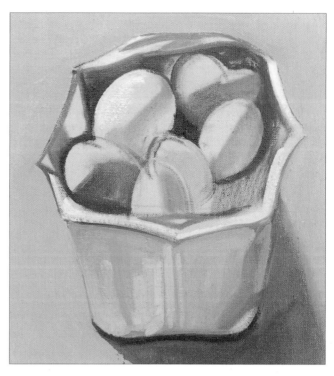

12 Container: paint the front of the container using varying tonal mixes of ivory black, zinc white and yellow ochre light.

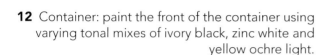

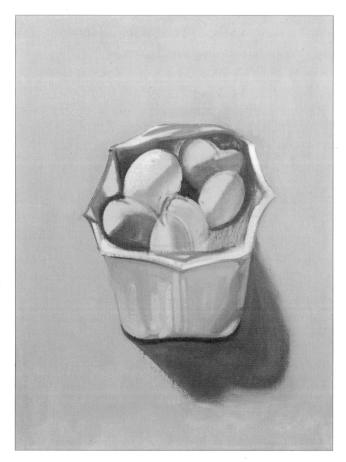

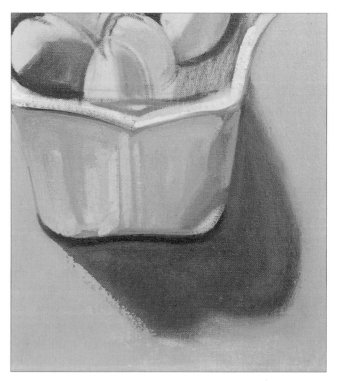

13 Background: judge the initial block-in against the eggs and the container that you have painted and modify it as necessary. Softly blend the paint using wet-in-wet with the previous green (see step 7).

14 Dark values: strengthen the main cast shadow by using the same mix as before (see step 3), but made slightly greener by the addition of yellow ochre light, ivory black and a little gold ochre. Add the shadow-line under the container with a little burnt umber.

15 Eggs: add the light values, giving the eggs more colour, using a soft No. 4 brush to create subtle transitions. Define and strengthen the outlines by deepening the shadow behind the eggs. For the duck egg at the front, use titanium white, a little terra rosa and yellow ochre light. For the pale chicken egg use a less pink mix of yellow ochre light, gold ochre and titanium white. For the goose egg use titanium white, yellow ochre light and a tiny amount of burnt umber.

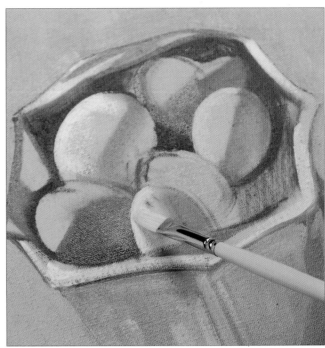

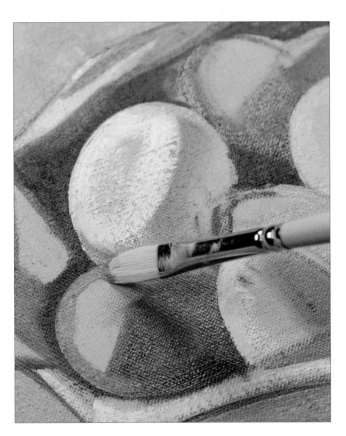

16 Using a mix of titanium white, zinc white and a little ivory black, develop the light values of the goose egg. Add a little gold ochre for the reflective shadow at the top and bottom of the egg, which gives it a rounded appearance. Mix a rich golden pink of yellow ochre light, terra rosa and zinc white for the left-hand edge of the chicken egg.

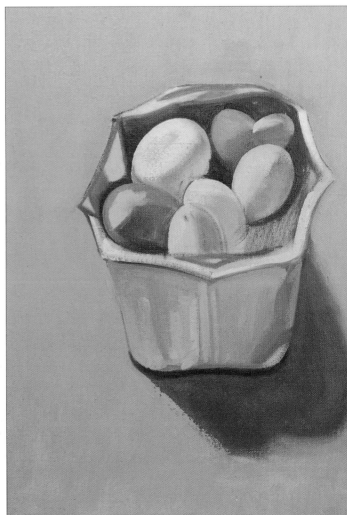

17 Use combinations of titanium white and zinc white with a tiny amount of ivory black and/or yellow ochre light for the light values on the palest eggs. Soften the transition between the light and shaded areas using either a soft brush or your finger. For the pale brown egg on the right, substitute the yellow ochre light with terra rosa, and for the brown egg at the rear use yellow ochre light, burnt umber and burnt sienna. For the quail's egg use ivory black, yellow ochre light and gold ochre.

18 Shadows: strengthen the shadows inside the container, at the same time heightening the shapes of the eggs. Use violet-brown/grey mixes of gold ochre, yellow ochre light, burnt umber and ivory black in varying proportions, using a more grey mix to define the lip of the container, its outline and the shadows within it.

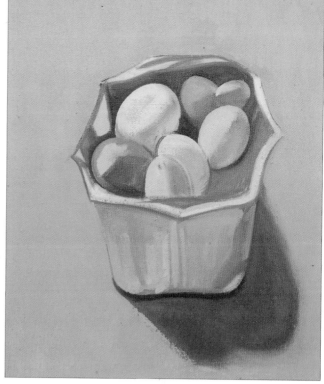

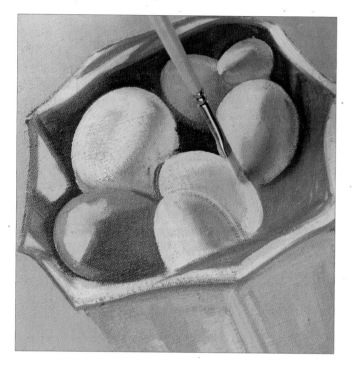

19 Reflected lights: place these in the shaded areas along the underside of the pale blue egg and the pale brown egg. Continue to use the same mixes as before but vary the proportions slightly to create subtle variations in colour.

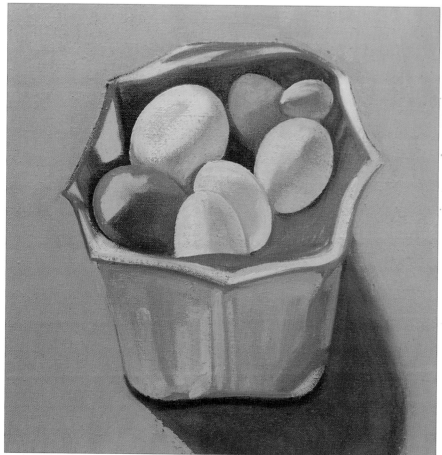

20 Contrasts and transitions: qualify the shadows and reflected lights where necessary by accentuating them with firm drawing and stronger dark tones. Soften the tonal transitions within the eggs using either your finger or a soft paintbrush. Sensitivity to edges, whether soft or sharp, will help convey the form.

43

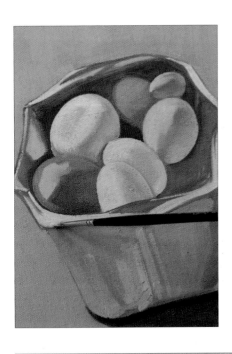

21 Container: sharpen up the form by defining the outline with a No. 4 soft, round brush. Use a mix of yellow ochre light, burnt umber and ivory black. Add further highlights to the rim using titanium white, a little yellow ochre light and a little terra rosa.

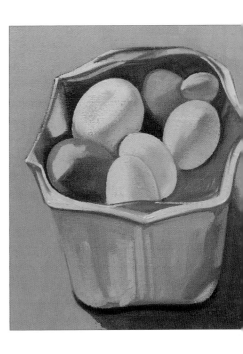

22 Complete the highlights, sharpen contours and put in any mid values using titanium white, ivory black and a little burnt umber.

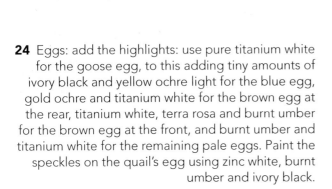

23 Add the vertical dimples on the inside using the same mid value as before. Put in the reflections using the mixes used for the eggs.

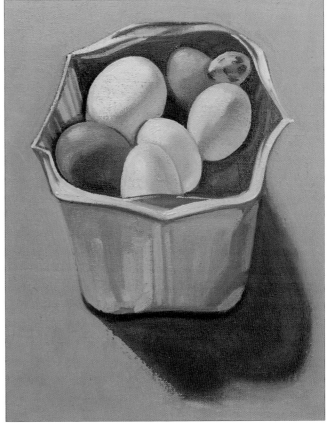

24 Eggs: add the highlights: use pure titanium white for the goose egg, to this adding tiny amounts of ivory black and yellow ochre light for the blue egg, gold ochre and titanium white for the brown egg at the rear, titanium white, terra rosa and burnt umber for the brown egg at the front, and burnt umber and titanium white for the remaining pale eggs. Paint the speckles on the quail's egg using zinc white, burnt umber and ivory black.

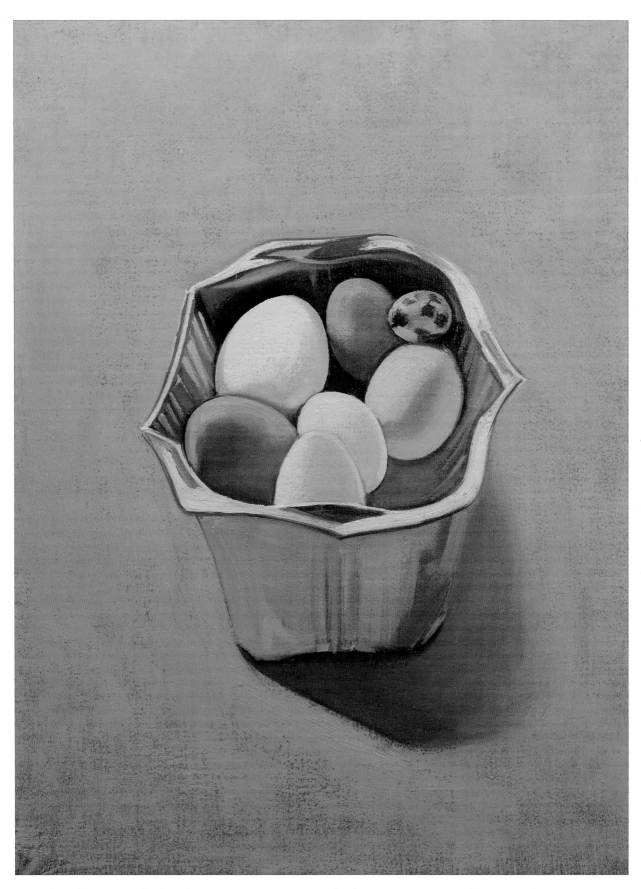

Complete the painting by heightening any contrasts you think necessary.
This is better done on another day, when you can be more dispassionate
about the picture.

Bottles

This second demonstration uses a palette of saturated colours. This gives you a fuller chromatic range to explore. The subject is designed to offer colours that are intense and high keyed, as well as grey values from black to white.

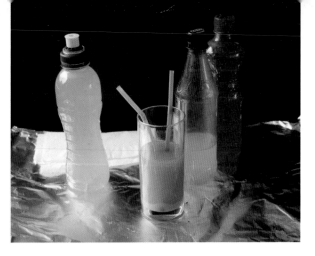

The composition.

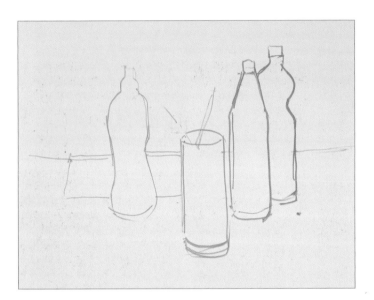

1 Composition: draw in the objects using a mix of Winsor lemon and alizarin crimson diluted with turpentine. Use a No. 4 filbert brush.

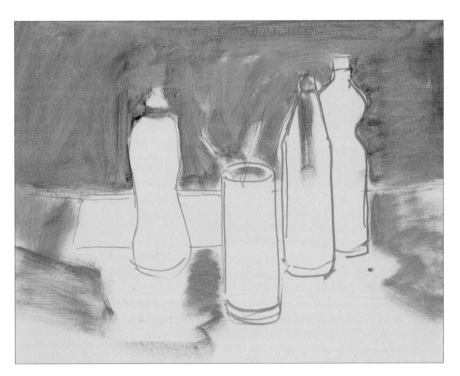

You will need

Primed canvas or board, 25 x 30cm (9¾ x 11¾in)

Paintbrushes: Nos 2 and 4 soft round, No. 4 filbert and No. 10 round hog-hair

Burnt sienna and ivory black acrylic paint

Turpentine, stand oil, white spirit (for cleaning brushes), rags and palette

Colours (clockwise from left):

cerulean blue, French ultramarine, alizarin crimson, cadmium scarlet, cadmium yellow, Winsor lemon, titanium white, zinc white

2 Underpainting: you need to retain the white ground, as its brilliance will help convey the saturated colours of the bottles. The white ground must be neutralised with a thinned layer of burnt sienna and ivory black acrylic paint over the area of the black background. Use a large round brush or a rag.

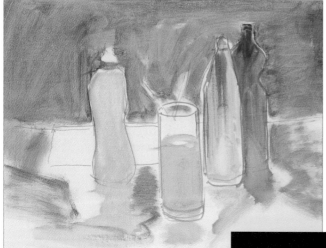

3 Bottles: broadly apply the following mixes using a No. 10 round, hog-hair brush: Winsor lemon and alizarin crimson to the red bottle and the orange glass, Winsor lemon and French ultramarine to the green bottle, and cerulean blue and French ultramarine to the blue bottle. Do not forget to include the reflections in the cooking foil. Keep the paint lean by adding a little turpentine or by working a little paint over a greater area.

4 Dark values: to achieve a neutral dark tone for the background, make a slightly blue mix to compensate for the warm underpainting. Use a mix of French ultramarine, alizarin crimson, a little cadmium yellow and even less zinc white. Work carefully around the shapes of the bottles.

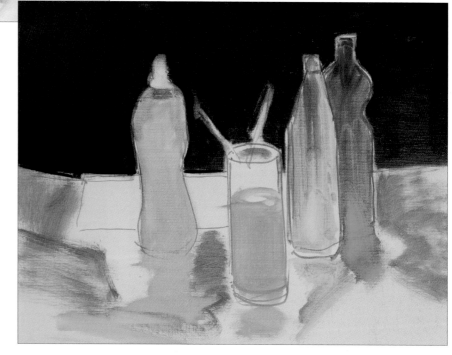

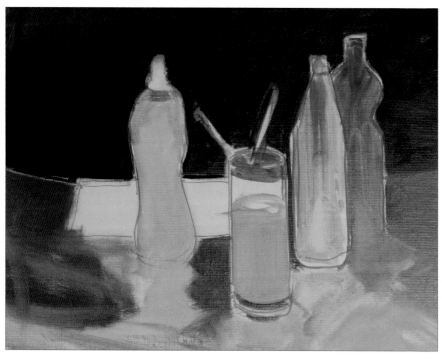

5 Using the same colours but varying the proportions in the mixes, put in the dark areas on the reflective surface and within the base of the glass.

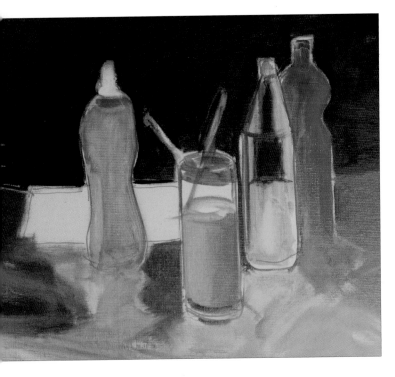

6 Bottles: put in the darker values and indicate the surface of the liquids. For the green bottle use a mix of French ultramarine, Winsor lemon and a little alizarin crimson; for the orange liquid use alizarin crimson, cadmium yellow and a small amount of cerulean blue; for the red bottle use cadmium scarlet and a little Winsor lemon; and for the blue bottle use pure cerulean blue with a little stand oil to increase its translucency. Cerulean blue is also used for the drinking straw and, with a little Winsor lemon added to it, the reflection in the base of the glass, down the side of the glass and down the side of the green bottle.

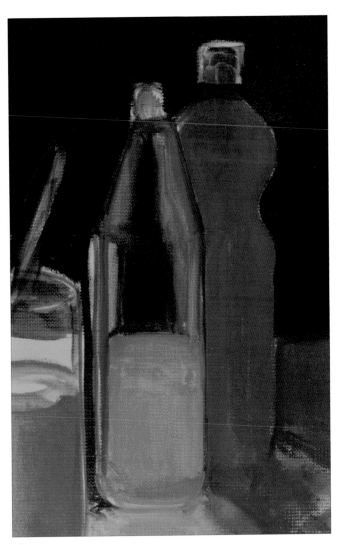

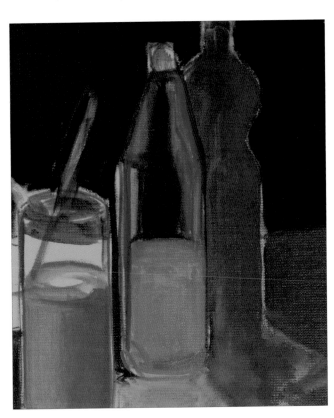

7 Green bottle: mix cerulean blue and Winsor lemon for the liquid. Apply the paint, allowing the underlying paint to show through. Add a little more cadmium yellow for the liquid's surface. Using Winsor lemon, cerulean blue and a little French ultramarine, define the sides of the bottle. Use the same combination of colours for the dark area in the top part of the bottle. Add a tiny amount of cadmium yellow to the mix for the stronger green at the base.

8 Red bottle: mix alizarin crimson, Winsor lemon and a little cerulean blue and put in the reflected colour from the green bottle down the left-hand side. Use the same mix for that part of the red bottle that is visible through the green bottle. Put in the space below the cap with a mix similar to that used for the background and use the same colour to sharpen the contours of the red bottle.

9 Bottle caps: for the dark tone of the red bottle cap, mix alizarin crimson, cerulean blue and a little Winsor lemon and apply it with a No. 4 filbert brush. For the lighter tone, mix cadmium scarlet, alizarin crimson and a little zinc white. Paint the cap of the green bottle in a similar way using alizarin crimson, French ultramarine and a little cadmium yellow. Make the lighter tone for the top of the cap by using less alizarin crimson. Paint a reflection from the red bottle down the right-hand side.

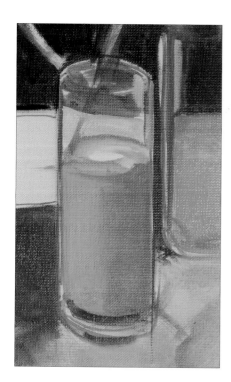

10 Glass: sharpen the side of the glass with the grey tone used for the background, and develop the contrasts in the orange by using alizarin crimson, cadmium yellow and a little cerulean blue. Mix French ultramarine, zinc white and a little alizarin crimson for the part of the napkin behind the glass. Use the same mix for the reflected light on the right-hand side of the glass. Put in the reflection from the green bottle using Winsor lemon and cerulean blue.

11 Blue bottle: apply a mix of alizarin crimson, French ultramarine and a dot of Winsor lemon to the black cap; with the dark background mix define the shape of the bottle.

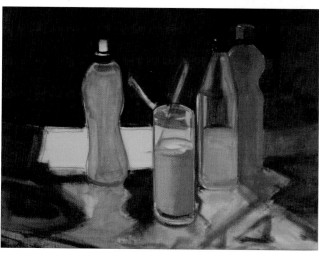

12 Reflective surfaces: begin with the darker tones, for which you should mix a good quantity of Winsor lemon, French ultramarine, alizarin crimson and a little zinc white. By varying the proportions of this mix you can create the various tones. For example, make the mix more blue or more green depending on the colour of the reflection.

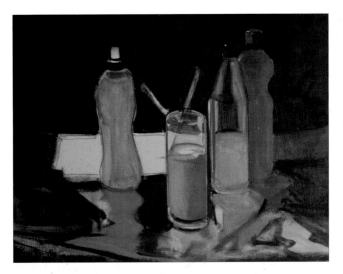

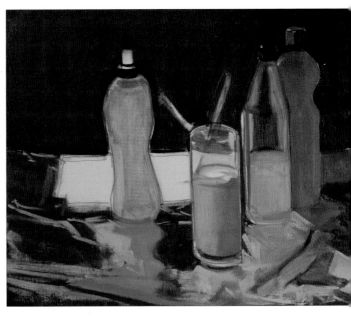

13 Coloured reflections: strengthen the coloured reflections by mixing cerulean blue and Winsor lemon for the green lights. For the red lights, mix Winsor lemon and cadmium scarlet; for the blue lights, cerulean blue and a little zinc white and for the orange lights use cadmium yellow with tiny amounts of alizarin crimson and zinc white. A little turpentine and stand oil will aid the fluidity and translucency of the paint. Correct any edges of the reflection using the adjacent background colour.

14 Sharp highlights: mix titanium white with small amounts of alizarin crimson, Winsor lemon and cerulean blue. Vary this mix to obtain a subtle range of colour. Apply the paint boldly but with a light touch so as not to pick up the underlying colour.

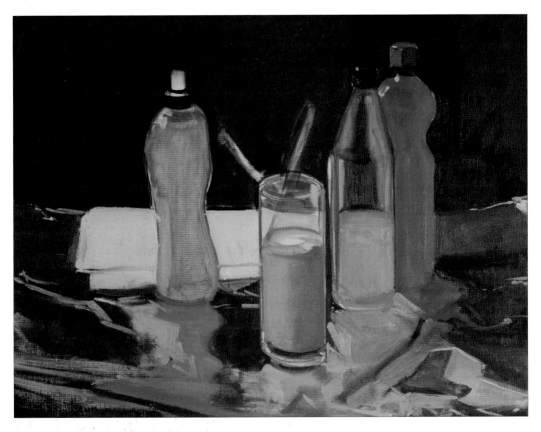

15 Napkin: for the napkin use a mixture of titanium white, zinc white, French ultramarine and alizarin crimson. For the shadows use the same mix thinned with turpentine and stand oil but omit the titanium white. Apply the paint with a No. 4 filbert brush.

16 Dark values: with a large quantity of the dark tone mix (see step 4), deepen the background with a more opaque layer. Make the tone slightly more blue on the left-hand side by adding a little zinc white and French ultramarine as the light falls on this side. Apply the paint with a large, soft brush to avoid leaving brush marks that, in a dark tone, will be refractive and destroy the depth of tone. Introduce this dark value into the reflective surface working wet-in-wet so that it blends with the tone underneath.

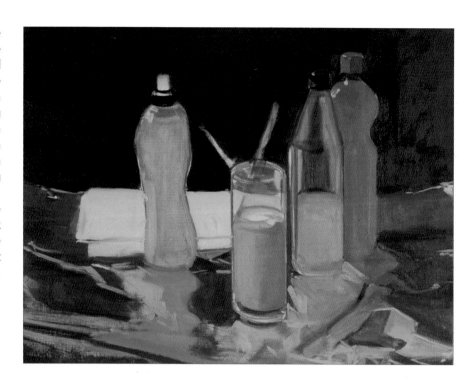

17 Blue bottle: with a No. 4 filbert brush apply a mix of cerulean blue and small amounts of zinc white and French ultramarine, leaving the lighter areas untouched.

18 Paint in the light areas on the left-hand side of the bottle using zinc white, titanium white and a little French ultramarine. For the violet highlights add a little alizarin crimson to this mix. Finally, add tiny reflections to the cap using the same grey as used in the reflective surface.

19 With predominately titanium white, a little French ultramarine and Winsor lemon, paint the strong highlights in the cap using a No. 2 soft, round brush, then strengthen the surrounding black area.

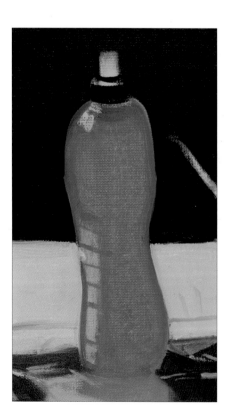

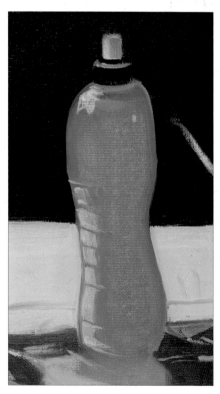

20 Orange glass: put in the surface of the liquid using mixes of alizarin crimson, cadmium yellow and Winsor lemon. Add a little cerulean blue for the cast shadow of the straw, applied with a No. 4 round brush. Put in the orange reflections in the base of the glass and the rim. Reinforce the ellipse of the liquid's surface.

21 To paint the reflections in the glass, mix titanium white and zinc white with a little alizarin crimson. Apply the paint vertically on the left-hand side using the same white used for the bright highlight in the base, rim and top of the glass. Continue the darker tone of the background where it is visible through the top of the glass. You may need to reduce this tone slightly by adding a little zinc white.

22 The straws: for the darker tones on the green straw, mix cerulean blue with Winsor lemon. For the light values add cadmium yellow and zinc white together. Draw in the edges of the straw with the point of a No. 2 soft brush. Repeat for the blue straw using mixes of cerulean blue, French ultramarine and a little zinc white.

23 Green bottle: using mixes of cadmium yellow, cerulean blue and French ultramarine, lighten the colour in the upper part of the bottle. The reflected light runs in a stripe down the left-hand side of the bottle. Mix this using titanium white, a little zinc white, alizarin crimson and a small amount of French ultramarine. Add the subtle reflected lights of cadmium yellow in the neck and in the base. Finally, add the cerulean blue strip on the left-hand side.

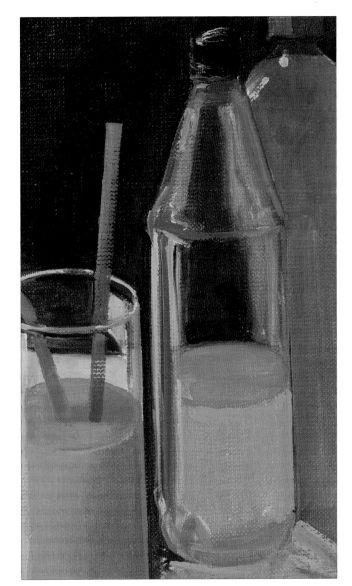

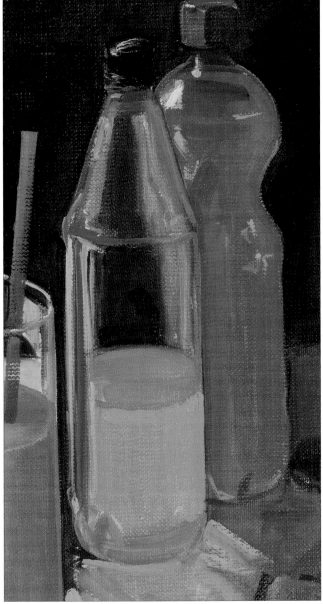

24 Red bottle: for the various bright highlights, mix titanium white, zinc white, alizarin crimson and cadmium yellow. For the cooler reflections, mix tiny amounts of zinc white, cadmium yellow, cerulean blue and alizarin crimson. Accentuate the shape of the bottle using the background colour.

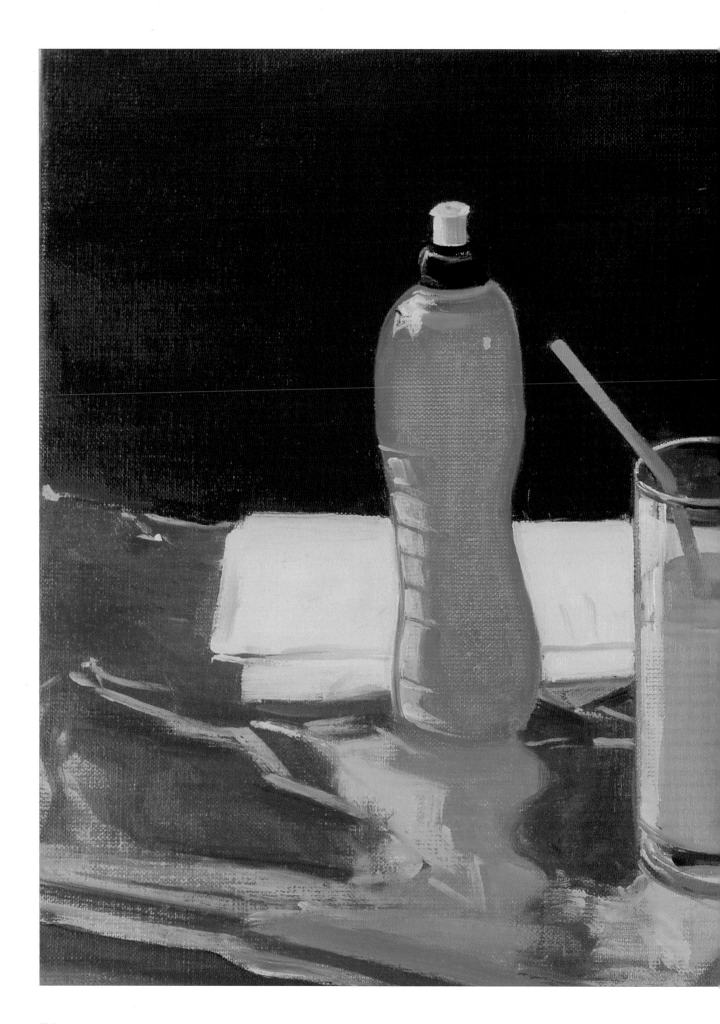

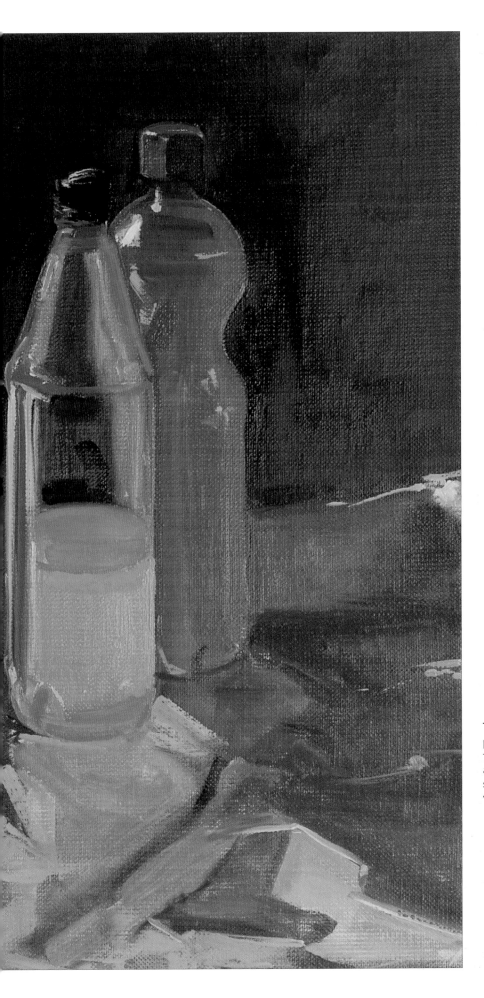

The completed painting. As in the previous demonstration, take time to scrutinise your work and correct any ambiguous forms or areas, strengthening any weaknesses in values and contrasts of colour.

Seascape

In this demonstration you are required to work from a drawing or coloured sketch. All painting is an act of imagination, no matter how objective the method. With this project you have the freedom of a more interpretive response, and drawing deficiencies are less apparent. For example, let the forms of the clouds be suggested by the movement of the application of paint on the support or accidents in the weave of the canvas.

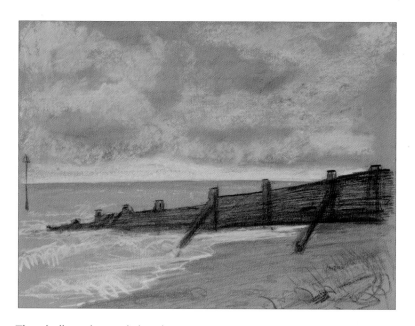

The chalk and pastel sketch.

Ground:
1 Apply a dilute mix of burnt sienna, raw sienna and Mars black acrylic paint using a rag.

You will need

Primed canvas or board,
30 x 20cm (11¾ x 7¾in)

Paintbrushes: Nos 4 and 10 filbert, Nos 4 and 6 soft round and No. 6 hog-hair

Mars black, burnt sienna and raw sienna acrylic paint

Turpentine, stand oil, white spirit (for cleaning brushes), rags and palette

Colours (clockwise from left):
ivory black, Prussian blue, cobalt blue, burnt umber, burnt sienna, terra rosa, yellow ochre light, Winsor lemon, Cremnitz white, zinc white

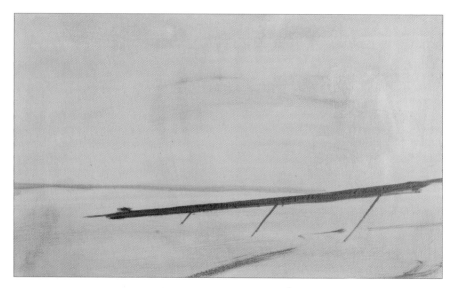

2 Composition: draw in the main elements of the painting using a No. 4 filbert brush. Dilute the paint with turpentine. I suggest using a mix of ivory black and yellow ochre light for the groyne, adding zinc white for the horizon line and using burnt sienna for the shoreline.

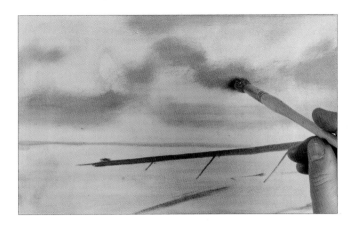

3 Clouds: with a mix of burnt umber, zinc white, ivory black and a little yellow ochre light, broadly establish the clouds with a large, round, hog-hair brush. Mix the paint with a little turpentine and stand oil to give some translucency to the clouds.

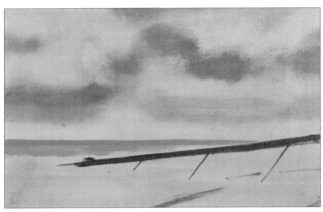

4 Horizon: mix together ivory black, yellow ochre light, a little Prussian blue and some zinc white to make a cold grey-green. Add a little stand oil to make the paint flow and apply it with a No. 6 round brush. Use horizontal brush strokes, allowing some of the background colour to show through to suggest waves.

5 Sea: using the previous mix but increasing the amount of yellow ochre light, scrub the paint in using a circular movement to suggest turbulence. Change to more linear strokes to suggest the ebb close to the shoreline.

6 Again using the initial grey-green mix, add a little Prussian blue and work the paint wet-in-wet using a small round brush. Apply with undulating strokes of the brush to suggest the rolling waves.

7 Groyne: draw in the base of the groyne with a mix of yellow ochre light, ivory black and a dot of Winsor lemon. Block in the colour using horizontal strokes of the brush to suggest the planking. Apply the paint unevenly with occasional additions of burnt umber using a No. 4 filbert brush.

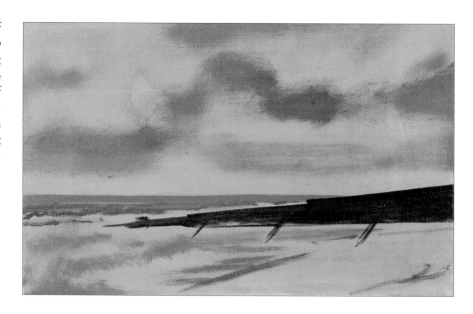

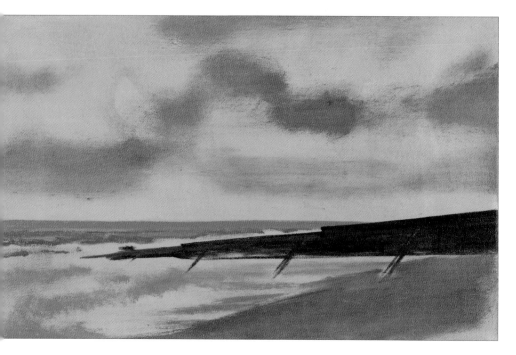

8 Beach: with a mix of yellow ochre light, burnt sienna and a little ivory black, take a No. 6 round hog-hair brush and work the paint across the surface of the canvas to allow the texture to play a role.

9 Sky: apply a mix of Cremnitz white, a tiny amount of Prussian blue and terra rosa to make a cold blue-grey. With a No. 6 soft brush and the addition of a little stand oil, brush the paint out to obtain an even covering. Use the tip of the brush to create the edge along the horizon.

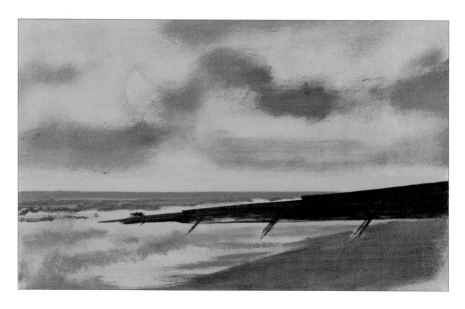

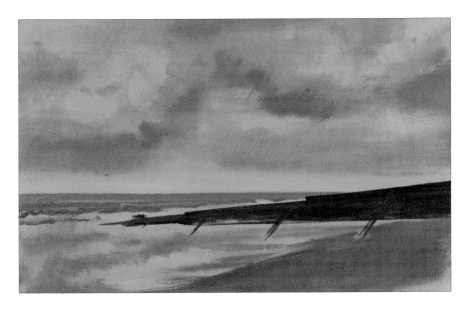

10 Create a mid tone of ivory black, zinc white, burnt umber and a little terra rosa. Use a No.10 filbert brush and lay on the paint thinly so that the underlying colour shows through. Partly overlay the existing clouds, and use horizontal brush strokes for the clear areas of sky and small, circular brush strokes for the clouds. Work a little of this mix into the sea.

11 When you have finished the above, drag a dry paintbrush diagonally across a portion of the clouds to suggest rain. The direction of this gesture will contrast with that of the sea, which runs from left to right.

12 Mix Cremnitz white, a tiny amount of Prussian blue and terra rosa for the lighter values in the sky. Apply the colour thinly and unevenly to suggest clouds, intensifying small areas by simply touching them with the brush and leaving areas unpainted to suggest a play of light in the sky.

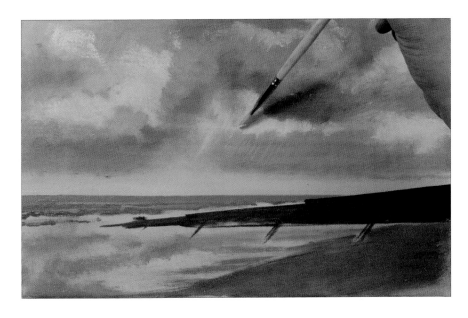

13 Beach: using a hog-hair brush, mix burnt sienna, yellow ochre light and Cremnitz white and dry brush the colour over the foreground, picking up the underlying texture of the canvas.

14 Groyne: mix ivory black, yellow ochre light and burnt sienna to paint in the shadows and details on the groyne, the slats, posts and supports. Vary the proportions of this mix with a little yellow ochre light to give a slightly green colour to the shingle.

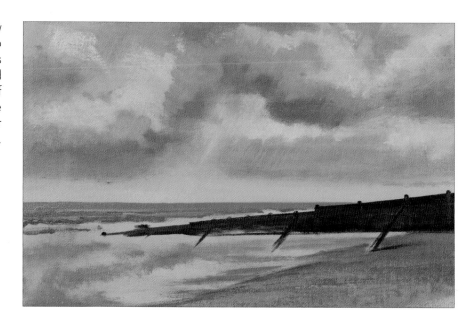

15 Add green highlights to the angled supports and posts using Winsor lemon, yellow ochre light and a tiny amount of Prussian blue.

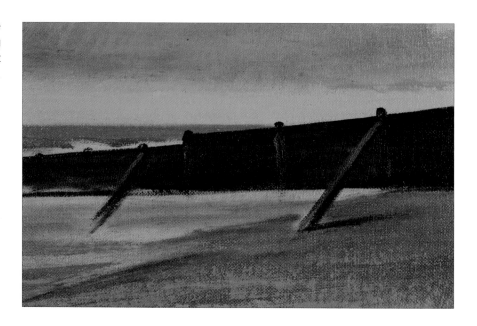

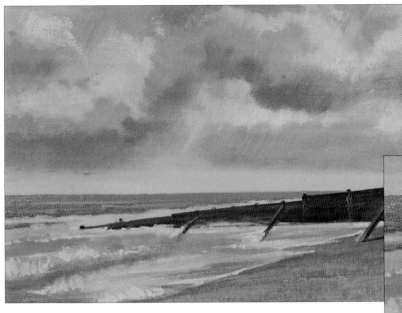

16 Waves: with a pastier mix of paint, made by setting the mixed colour of Cremnitz white and yellow ochre light aside on blotting paper to remove a little of the oil, take a No. 4 round brush loaded with pigment and paint the foaming waves.

17 Deepen the tone within the waves with a mix of burnt umber and yellow ochre light. Add a little burnt umber to a mix of Cremnitz white and yellow ochre light and paint the tops of the waves.

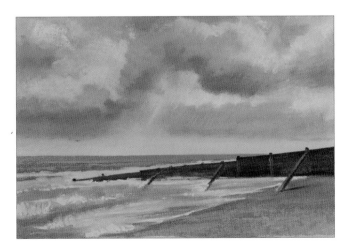

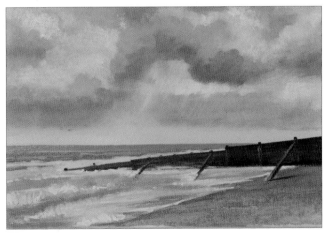

18 Sky: for the brightest elements of the sky, mix cobalt blue, zinc white and a touch of yellow ochre light. Soften the edges into the clouds using a No. 10 brush.

19 Clouds: accentuate the clouds by strengthening the transitions. Apply the paint using the full width of the brush. Using short brush strokes, introduce Cremnitz white with a little yellow ochre light for the lightest clouds.

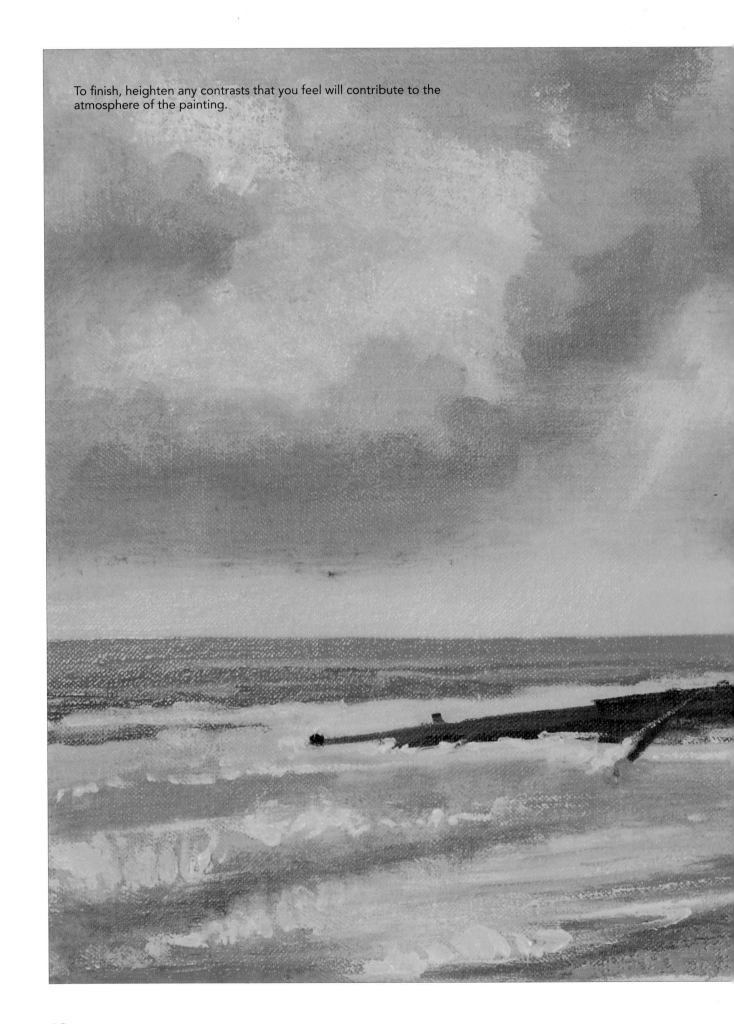

To finish, heighten any contrasts that you feel will contribute to the atmosphere of the painting.

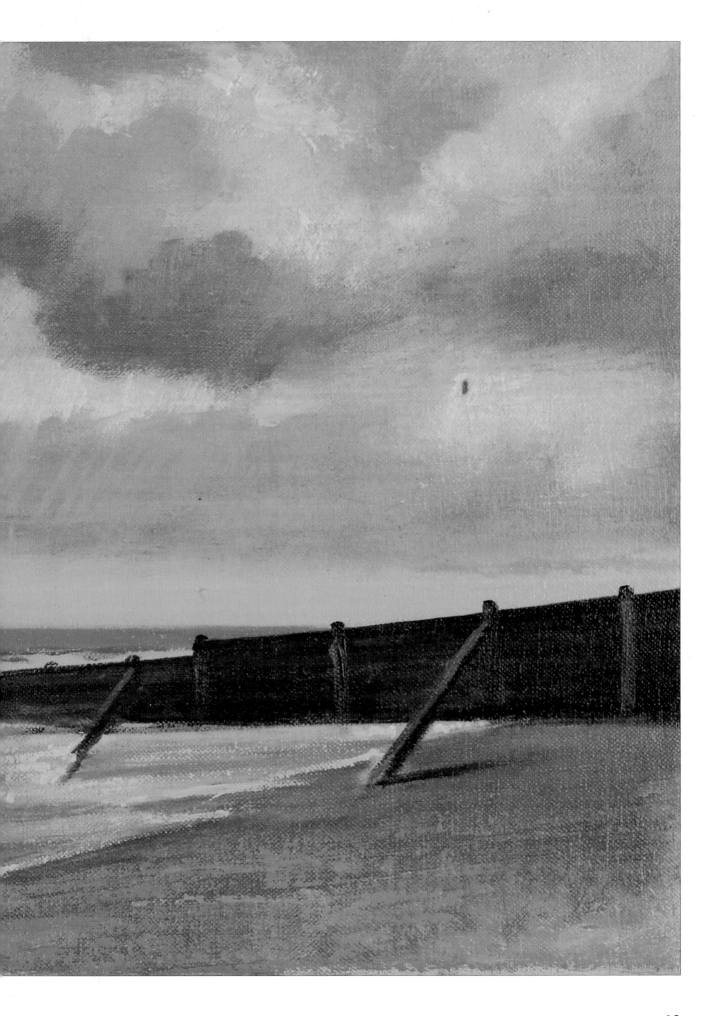

Index

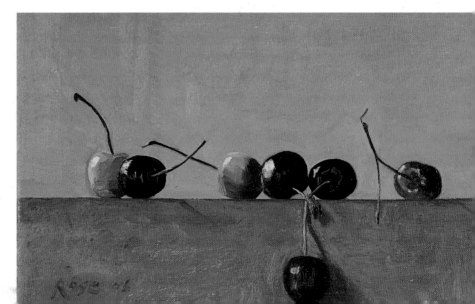

Cherries
30 x 20cm (12 x 7¾in)
Here the cherries are disposed like notes on a stave in music, their stalks setting up a rhythm across the composition.